THE HAPPY BABY BOOK

50 Things Every New Mother Should Know

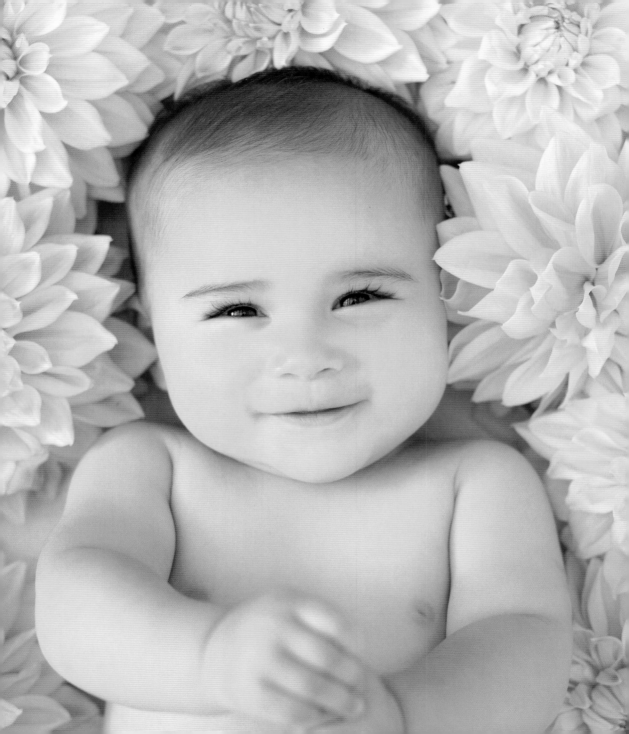

THE HAPPY BABY BOOK

50 Things Every New Mother Should Know

RACHAEL HALE

WRITTEN BY BILLIE LYTHBERG AND SIAN NORTHFIELD

Andrews McMeel
Publishing, LLC
Kansas City · Sydney · London

In association with PQ Blackwell

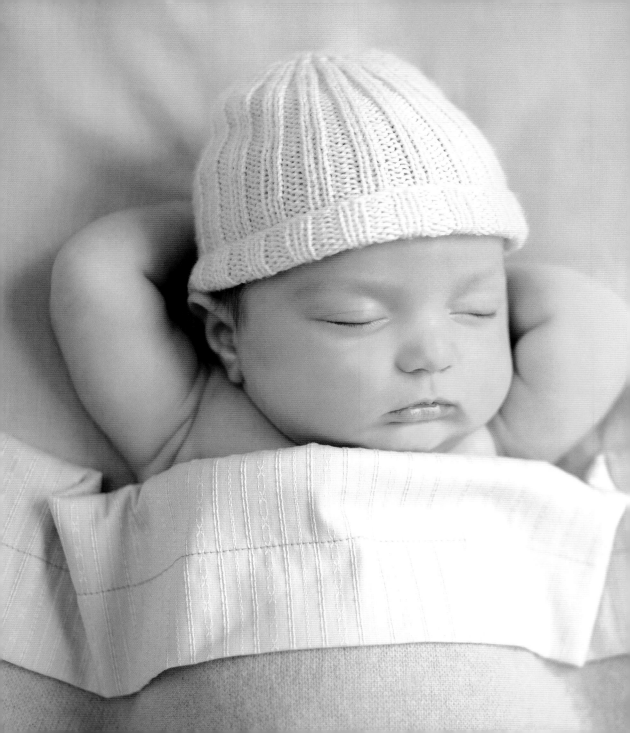

Preface

Here is a book by three women who love babies: one with a gift for capturing babies at their best—and worst—and somehow making them all look beautiful; two with babies of their own and a fascination for language and the power of words. It is a book of images and words that we hope will ease the journey that every new mother must take.

Every child's life begins the moment a woman is transformed into a mom. Some of us recognize our new incarnation instantaneously: the first glimpse of our newborn is enough to tune our instincts and senses in to this new role that somehow comes so naturally to us. Some of us approach motherhood with more deliberate steps: our goal in sight, we may nevertheless be surprised when we realize we have arrived at a more subtle transformation, achieved with time and effort. Neither journey is more magical than the other. Each is life changing, world shaking, exhausting, and empowering.

So, where to begin?

Touch your baby. Feel her soft skin. Stroke her sweetly furrowed brow and trace her softly sculpted ears. Look into her eyes, sniff the top of her head. Breathe with her. Inhale her scent and blow gently across her face. Mark her as your own. She is exactly what you wanted. Find the perfect name. Name it. Speak it. Claim it.

Take a photo and send it around the globe: this is my baby; my newborn; my new life. For one tiny moment, yours was the newest baby in the world. These days, that first photo probably isn't really the first of your baby; that privilege held by ultrasound and ultra-fantastic imaging. And it certainly won't be the last photo you take, nor should it be. Take as many as you can, record these precious days; they change all too quickly. Mark in time the good and the bad, and be prepared to look back on both through the rose-colored glasses of hindsight.

A baby! You have probably read for its arrival. You have probably read too much: books, magazines, Web sites. You know about diapers; you have the latest ergonomic, foolproof, guaranteed-sleep crib; and you've purchased a four-wheel drive, on-road/off-road, subway-and-shopping-mall-capable stroller. You've evaluated the advantages of breast over bottle, chosen a sleep guide, pre-enrolled at the best daycare, and folded and stored a lifetime of small clothes. You are ready. What else do you need?

Words.

You'll be offered plenty. Words to advise, encourage, and console. Many will be familiar: they are the truisms of motherhood. But when you are faced with a "mother lode" of work producing "the milk of human kindness" for your "babe-in-arms" who is crying out his "baby blues," and all you really want to do is "sleep like a baby," you might need some other words. Words that prevent you from "throwing the baby out with the bathwater"! Short and strong words that convey deep emotion with minimal effort . . . erudite and witty words to keep your adult sanity intact . . . lullabyes to soothe and calm . . . ditties to

enthuse and energize . . . euphemisms to make light of situations . . . synonyms for words that seem worn out with overuse . . . statistics with which to defend your actions . . . even our own tried-and-true recipes.

Within the pages of this book are images of beautiful babies matched with our favorite words. Words to laugh with, words to cry with, words to sing to, words to sigh with. Words from one photographer, two moms, and our mom-friends; and all our mothers, grandmothers, and great-grandmothers. Words that made us smile when we needed to; helped us cry when we needed that, too; some that made us laugh when laughter really was the only option; others that reminded us of life's small miracles; and a few that we've simply made up!

Together, we three give you fifty things we believe every new mother should know. Take heart as you read these words and gaze upon these images: there is a woman behind each one who is taking this journey with you.

And now for the disclaimer:

All advice has been tested in domestic households, but results may vary from family to family. This book contains fanciful statistics. This book will not tell you how to fold diapers or burp babies. It won't tell you how to get a fractious baby to sleep. This book is to remind you that becoming a mom is a miracle, and that even the world's best miracles require a little humor and a box of tissues.

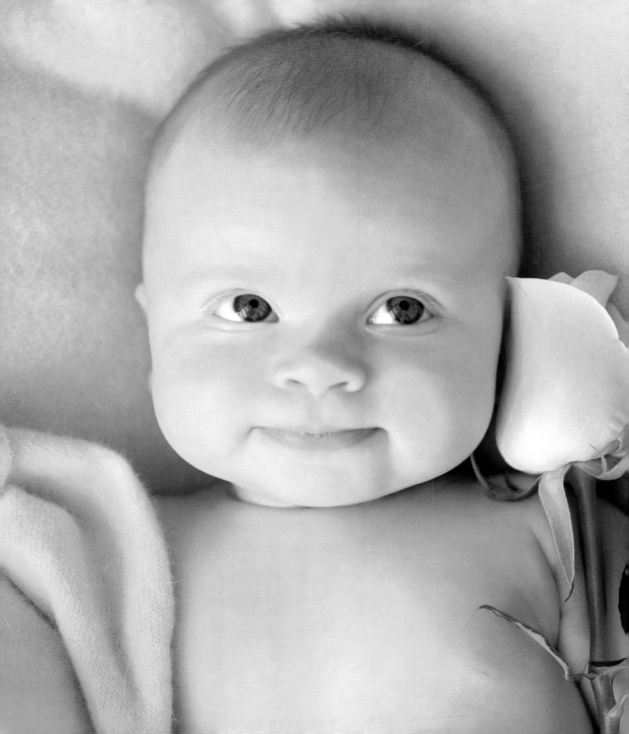

There is only one perfect baby in the world . . .
and every mother has it.

No. 1

No.2

Your baby will remind you that there
is much to be gained from living in the moment and . . .

No. 3

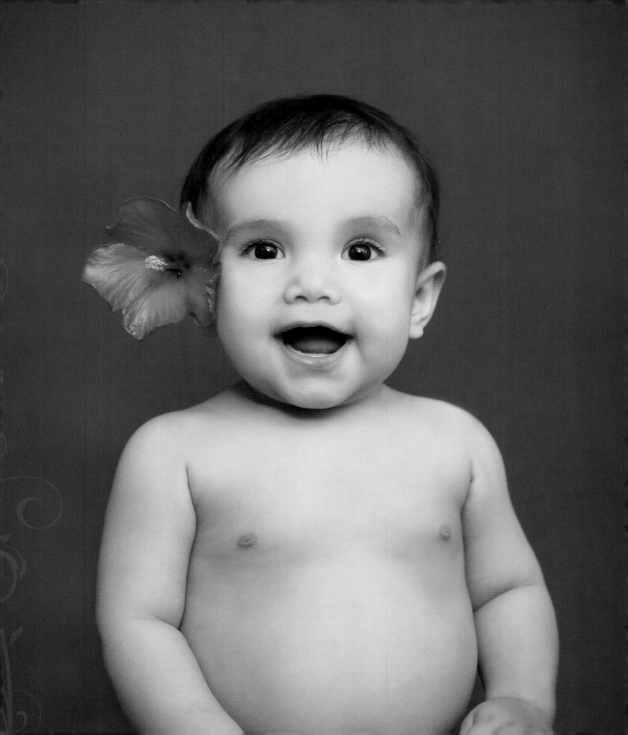

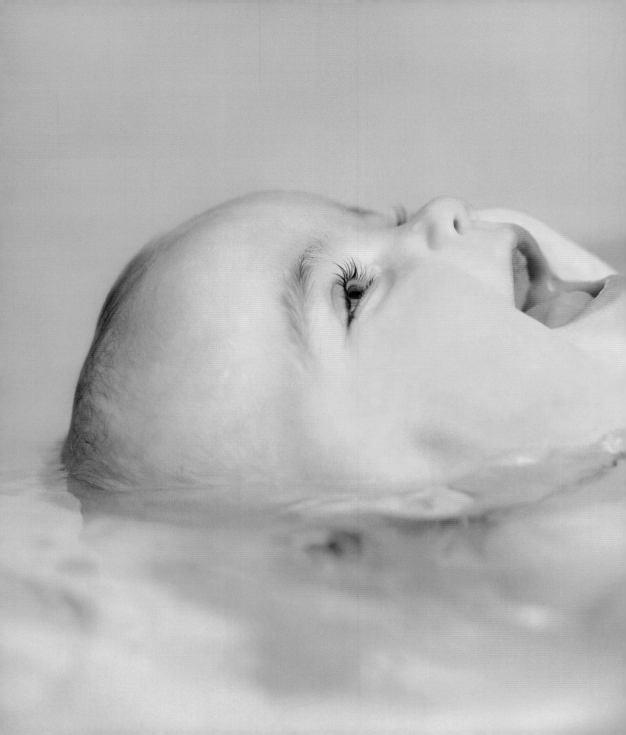

. . . that the smallest things in life bring the greatest pleasure.

Essential Survival List
for the First Week . . .

No. 4

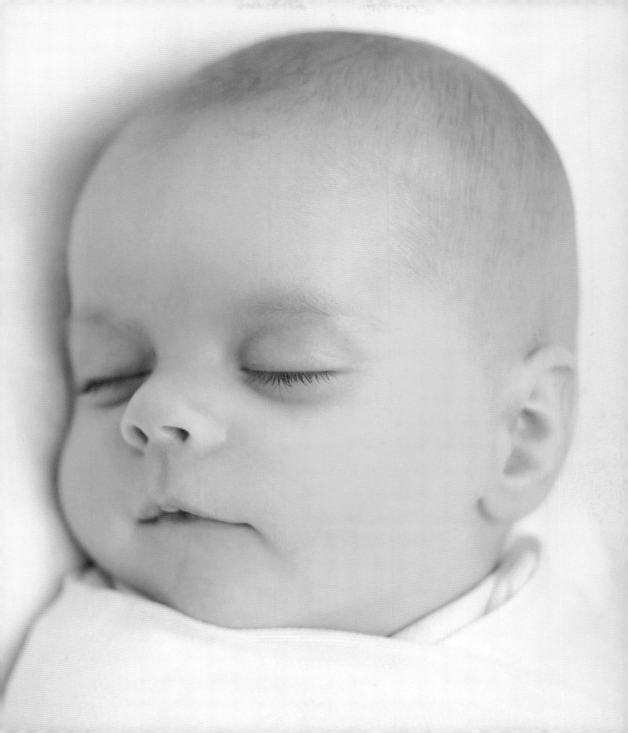

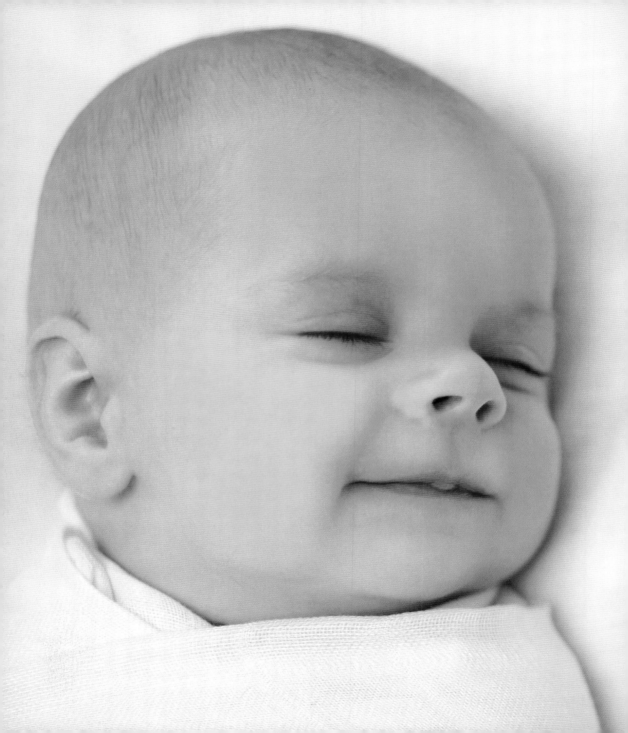

1. Chocolate (for medicinal purposes).
2. Diapers (at least twice as many as recommended).
3. Gossip magazines (preferably *Us Weekly* and *In Touch Weekly*).
4. Pulitzer Prize–winning novel to alleviate guilt about magazines (mostly for show).
5. Bathrobe that makes you feel sexy and gorgeous, and returns your body to prebaby proportions.
6. Eye cream.
7. Other moms who bring onesies and casseroles.
8. Childless friends who bring something hopelessly impractical for baby to wear, champagne, and more chocolate.

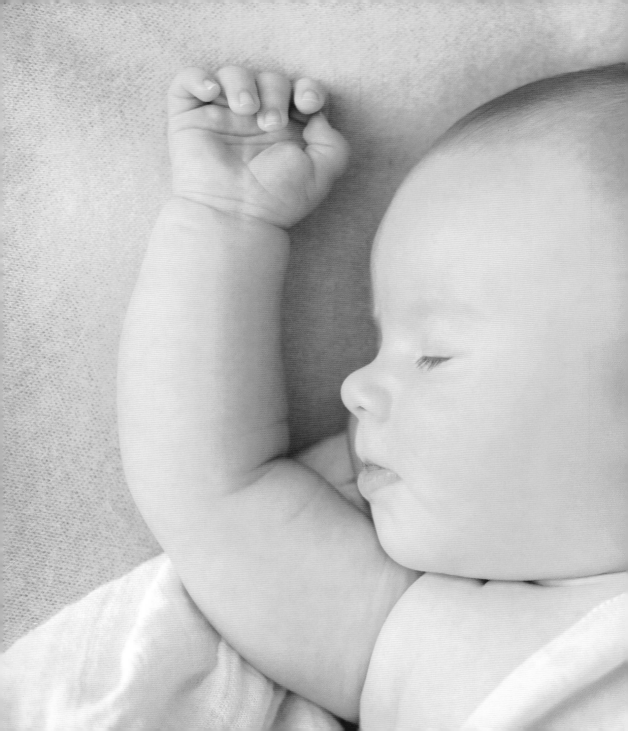

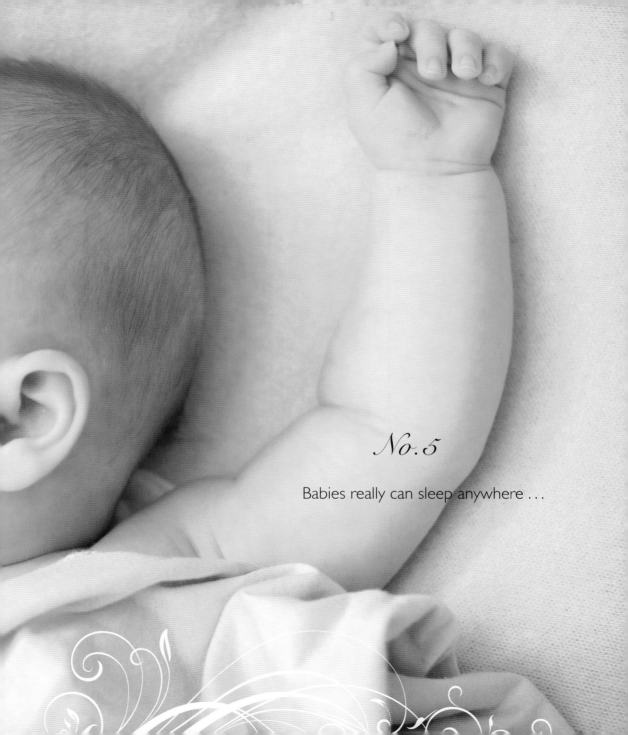

No.5

Babies really can sleep anywhere . . .

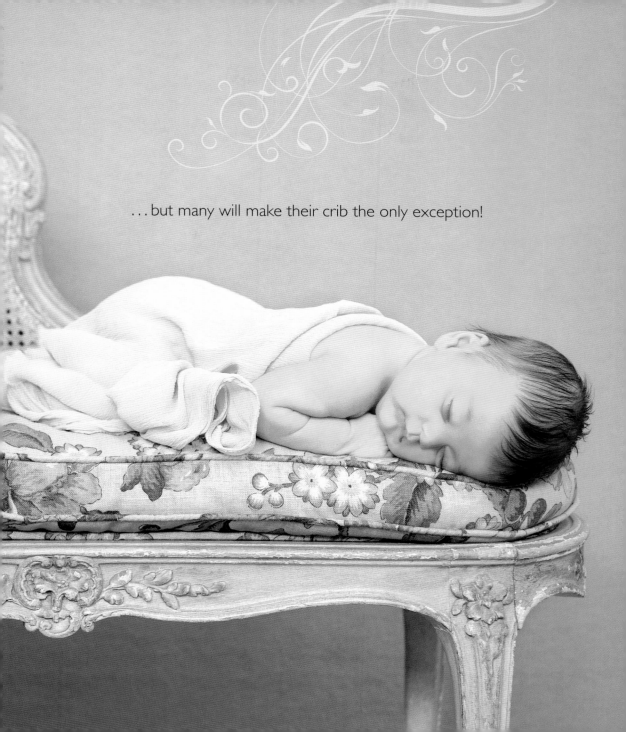

. . . but many will make their crib the only exception!

The Ten Commandments of Motherhood

No. 6

1. Thou shalt forsake a clean house.
2. Thou may never again have an uninterrupted conversation.
3. Thou shalt learn to shop unexpectedly.
4. Thou shalt not covet thy neighbor's social life.
5. Thou shalt now really honor thy mother and father.
6. Thou shalt no longer have all the answers.
7. Thou hast no further need of an alarm clock.
8. Thou must make five failed attempts before ever leaving the house.
9. Thou shalt wonder what thou ever did with thy time.
10. Thou shalt know it is all worth it.

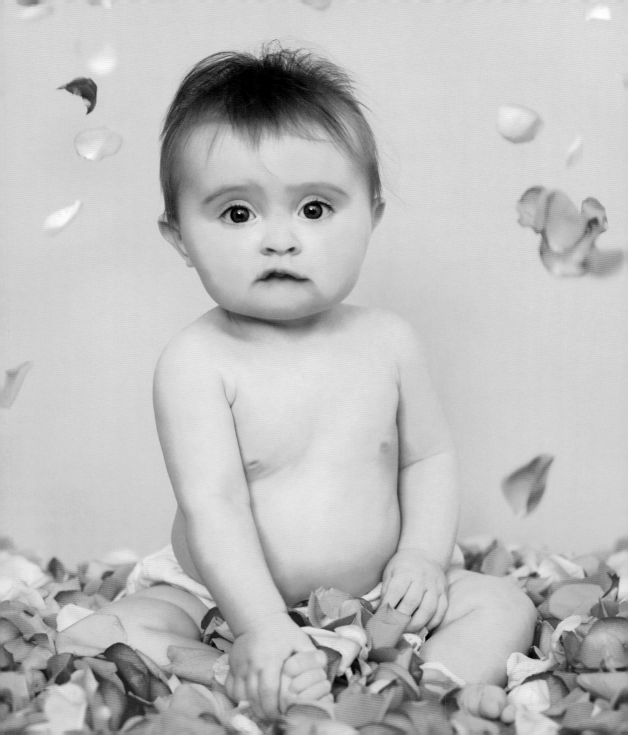

40%

of new moms will leave their baby in a restaurant.

No. 7

55%

of new moms will dress their baby in crazy outfits.

No. 8

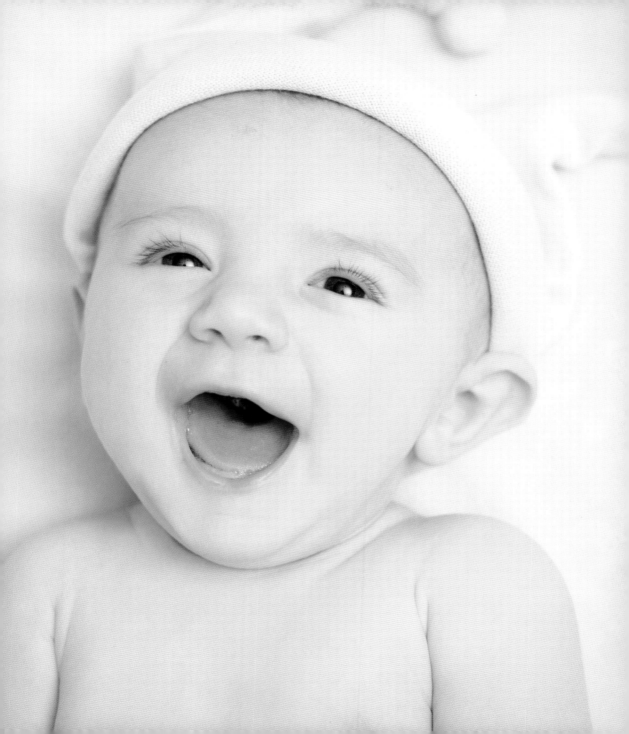

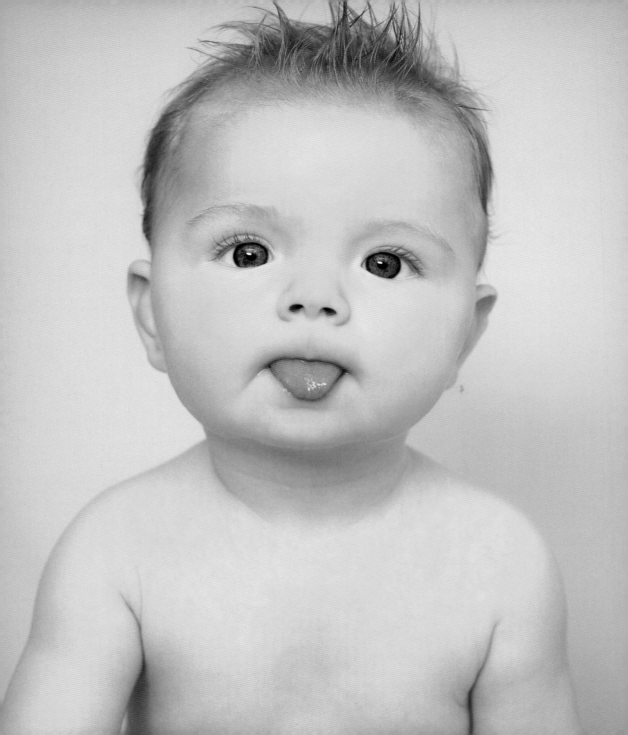

65%

of moms will run out of diapers at 3 a.m. at least once.

No. 9

75%

of moms will be ten minutes late for all appointments.

No.10

80%

of babies wake at the sound of their mom's
well-earned coffee break.

No. 11

100%

of babies will forgive you for your inexperience.

No. 12

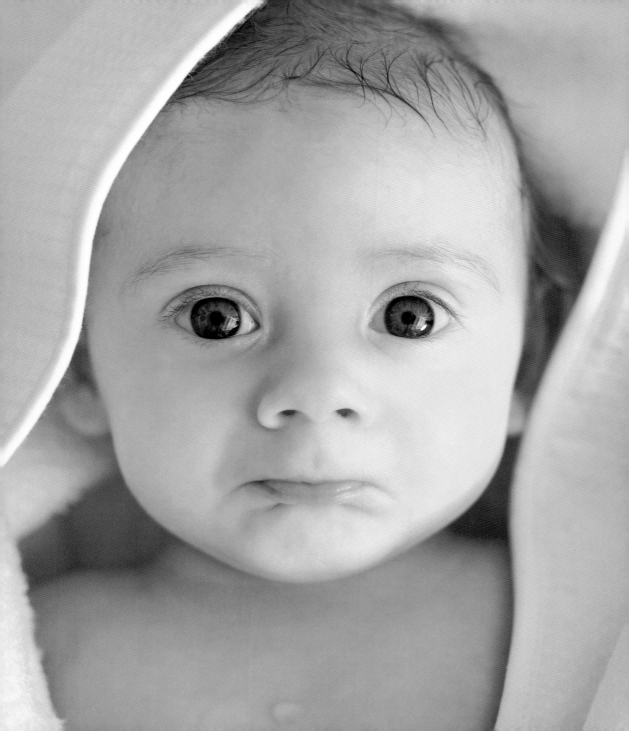

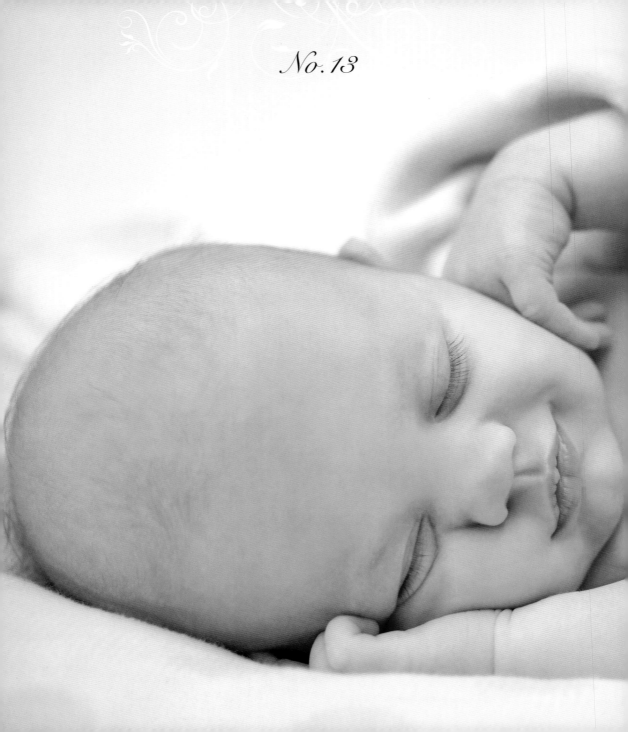

No. 13

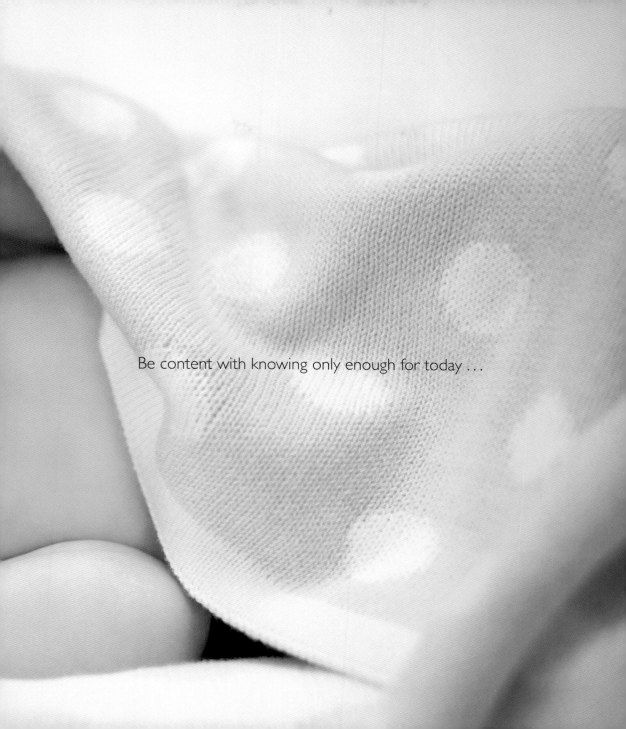

Be content with knowing only enough for today . . .

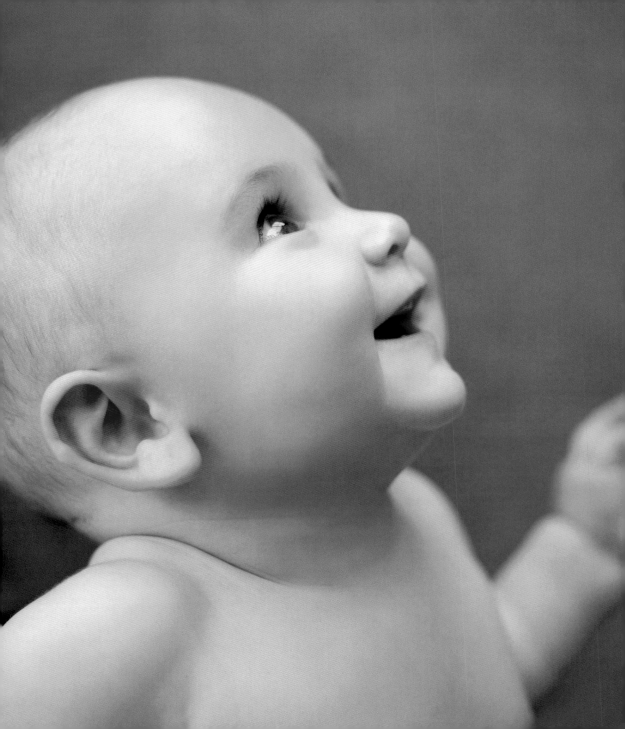

. . . because tomorrow always begins anew.

Physiological Differences You May Notice after Having a Baby

Your heart is bigger.
You have more laugh lines.
Your skin is elastic because babies need a soft lap to sit in.
Your vision has altered and you only have eyes for your baby.

No. 14

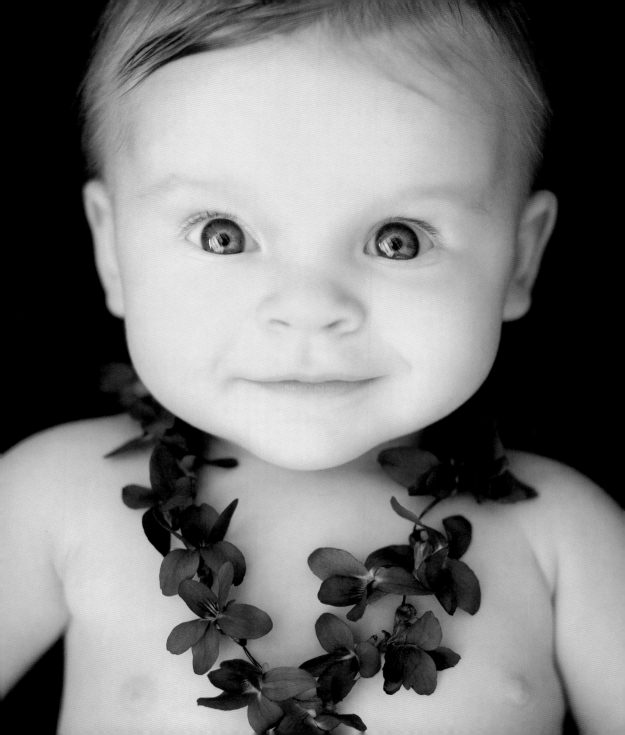

Happy Baby Recipe

1. Take at least one baby (prepared earlier).
2. Establish a routine.
3. Add milk.
4. Gently cuddle . . .
5. . . . then kiss to taste.
6. Pinch to test for sweetness.
7. Swaddle and leave to rest somewhere warm and dry (for as long as possible).
8. When doubled in size, discard routine.
9. Add a dash of independence and a cupful of security.
10. Mix in some culture to taste.

No. 15

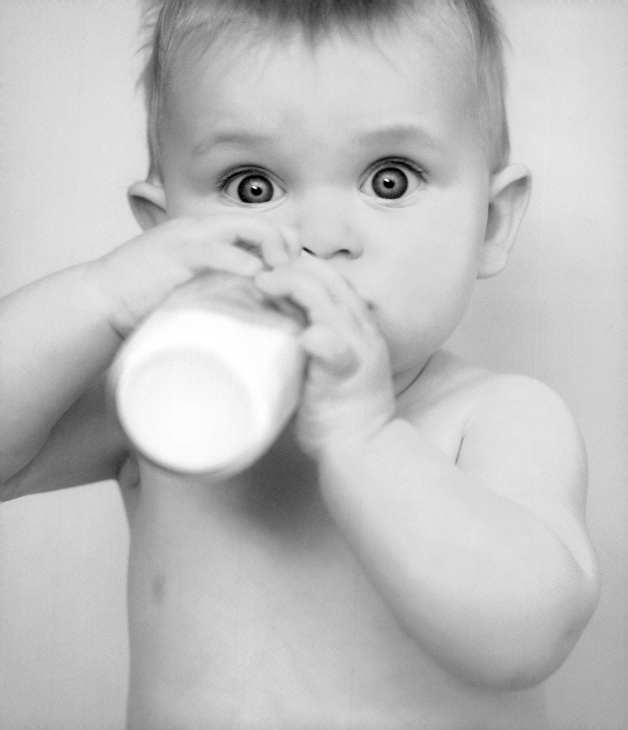

In reply to the question, "So, what do you do?"
try practicing the following:

"Actually, I make people.
Here's one I prepared earlier."

No. 16

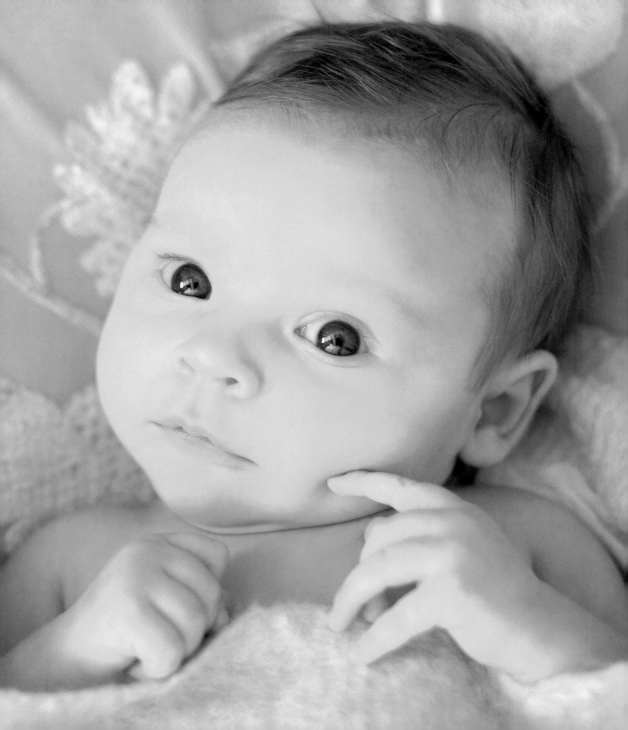

17

What new mothers really need from their friends

(as well as chocolate, flowers, and the reassurance

that they're doing everything exactly right.)

1. Acknowledge her baby as quite possibly the cutest ever born.

2. Envy her radiant glow and bountiful curves.

3. Admire her new lifestyle as genius and groundbreaking.

4. Compliment her casually bedraggled style.

5. Bring a dish; do the dishes; do her laundry.

Well-meaning but endless advice from others can be deflected . . .

No. 18

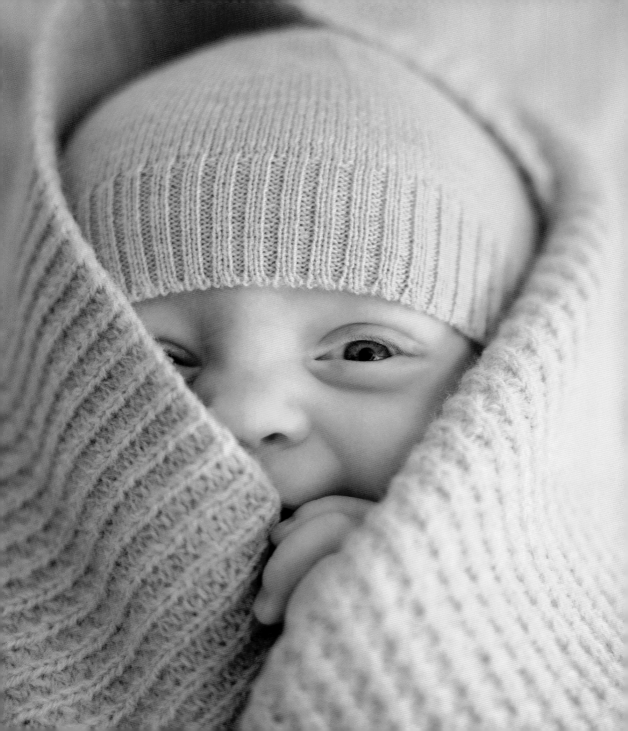

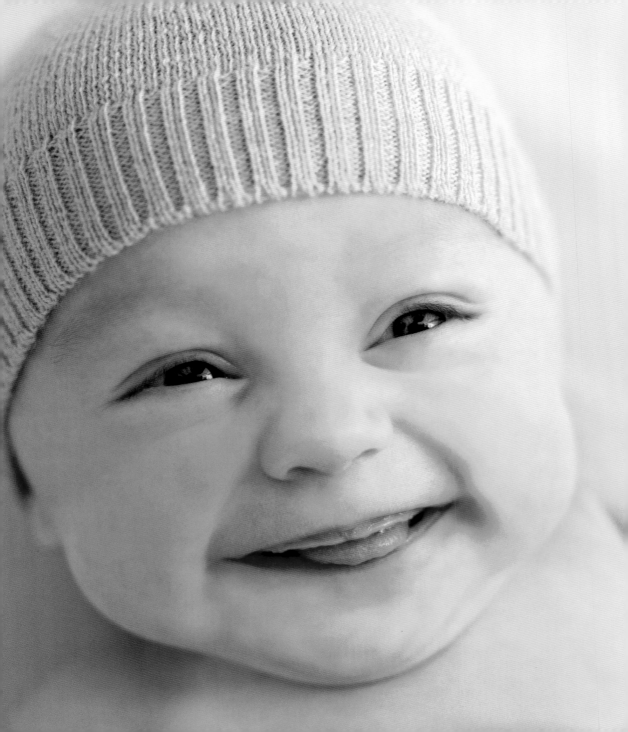

. . . with a request for their phone numbers so
you can recap at 2 a.m. when you actually need it.

Never wake a sleeping baby . . .

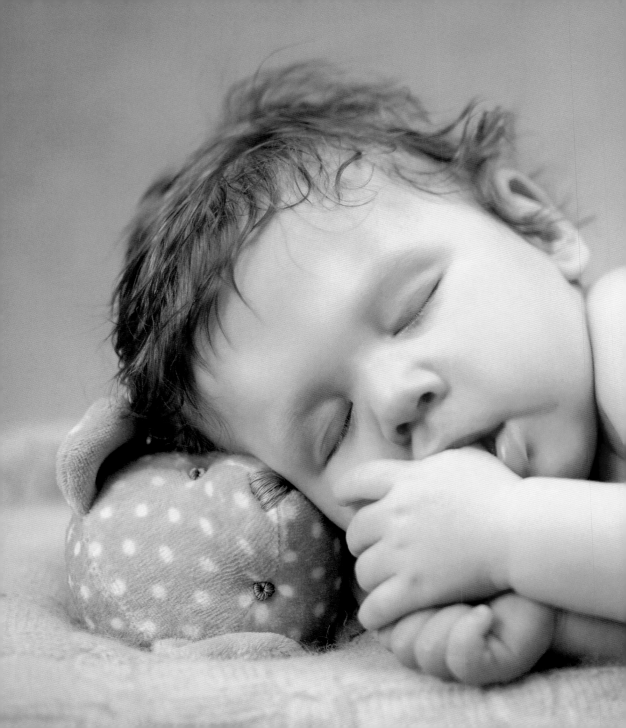

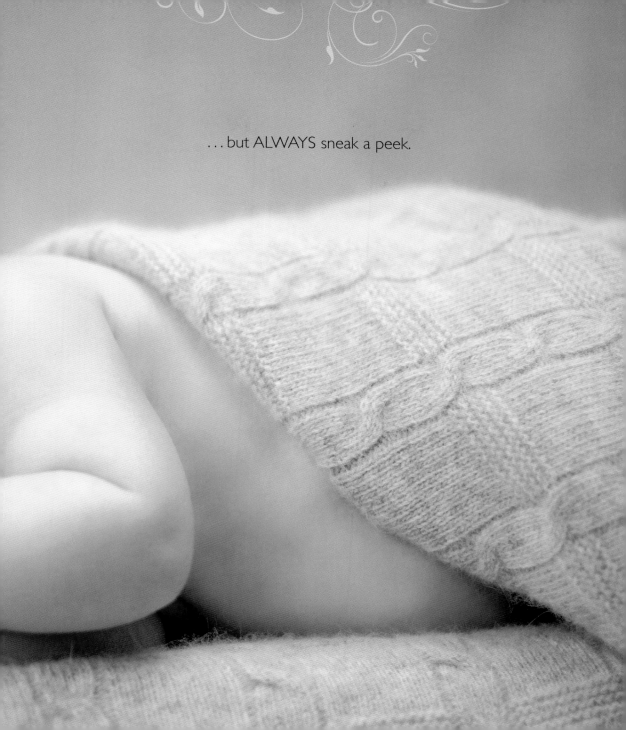

. . . but ALWAYS sneak a peek.

You will know your baby is destined
for a glorious career when . . .

She looks at you observantly (future artist).
She fills her diaper (future landscape architect).
She burps (future restaurant critic).
She coos (future linguist).
She kicks her feet (future Olympic athlete).
She waves (future sign language interpreter).
She stacks blocks (future property developer).
She sleeps through the vacuuming (future politician).

No. 20

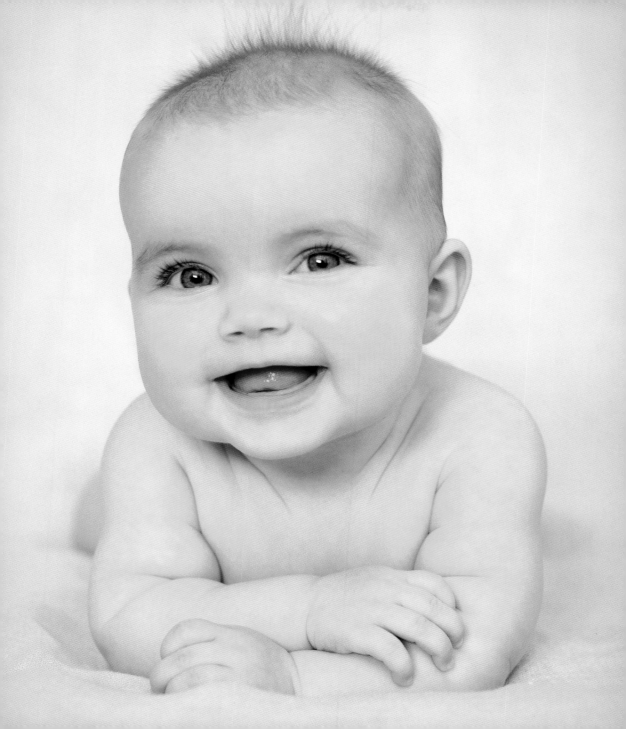

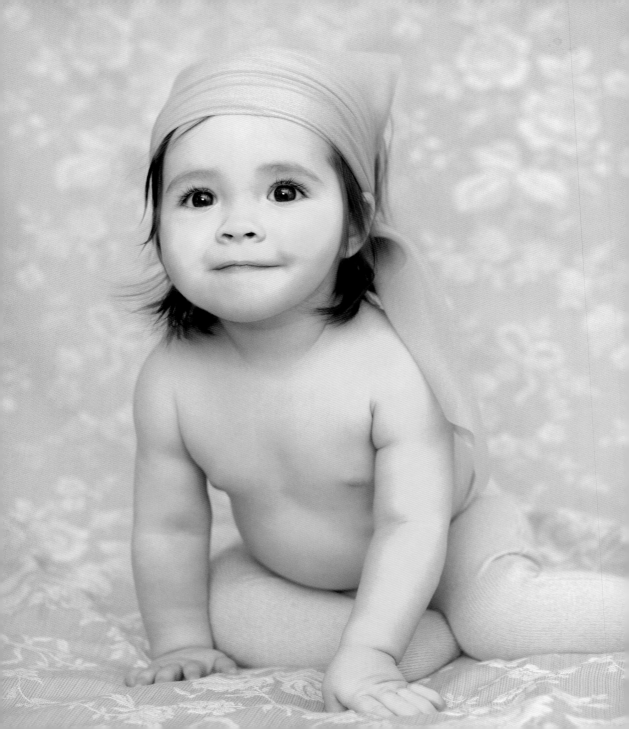

Remember, babies are more ruthless than you.
With just one smile they can melt your heart.

No. 21

Some days your baby is so cute you could eat him . . .

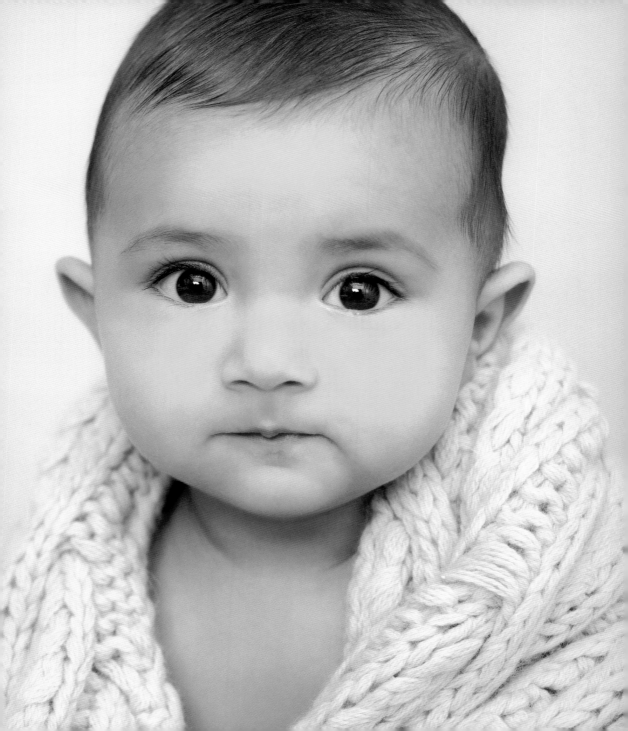

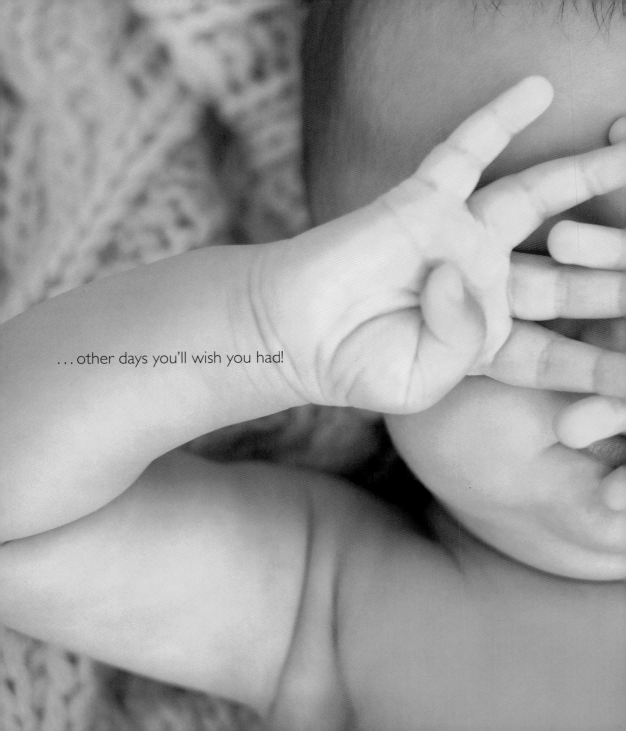

...other days you'll wish you had!

On those days when you find yourself saying to your baby,
"What, wet again? Just how many diapers am I going to change?,"

there is an answer:

No.23

Approximately

5,475!

Sometimes the best—and only—thing to do is . . .

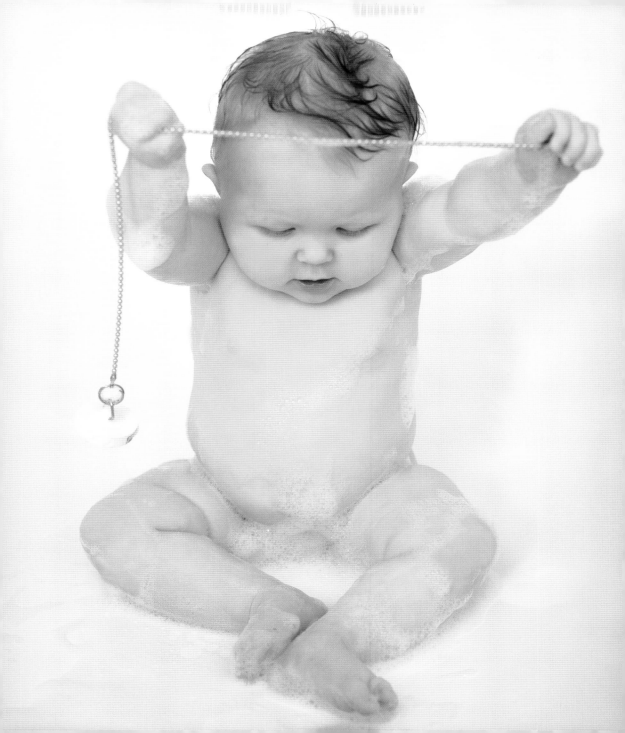

. . . smile.

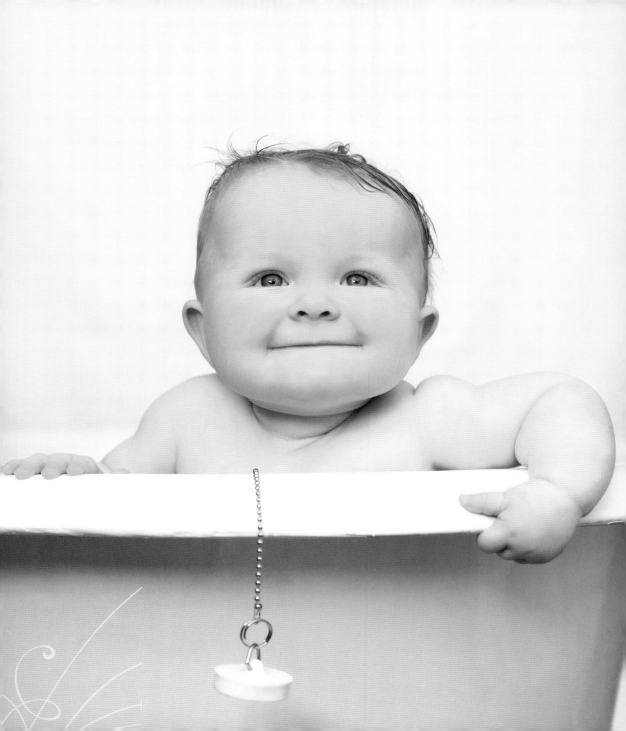

Whenever possible, baby clothes should have ears.

No.25

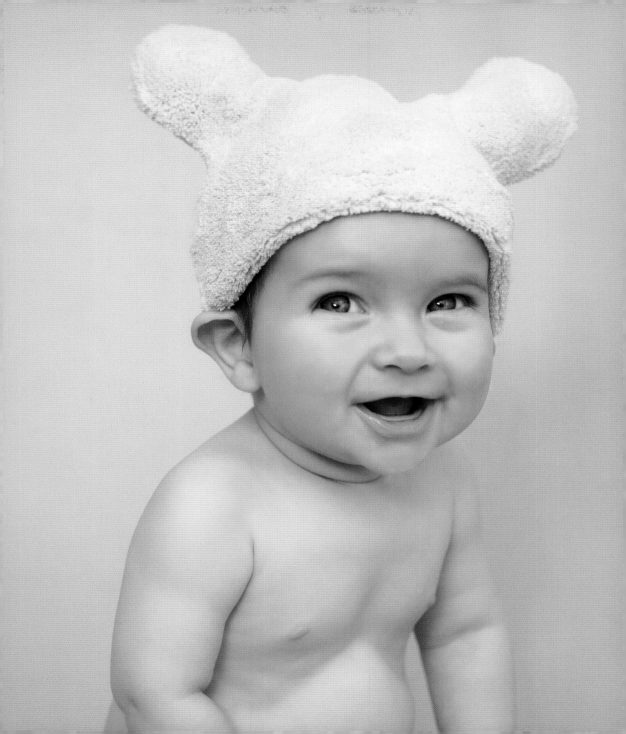

A Week of Babies

Monday's	Tuesday's	Wednesday's	Thursday's
child is overtired.	child is a little wired.	child just will not sleep.	child just loves to peep.

No.26

Friday's

child will fuss and fret.

Saturday's

child is always wet.

Sunday's

child won't shut her eyes.

…and all their moms deserve a prize!

Mom (American)
Mum, Mummy, Mother (British)
Mere (French)
Mutter (German)
Maji (Hindi)
Ammi (Urdu)
Madre (Italian)
Mae (Portuguese)
Nene (Albanian)
Inahan; Nanay (Cebuano)
Majka (Serbian)
Matka (Czech)
Moeder (Dutch)
Ema (Estonian)
Mem (Frisian)
Mana (Greek)
Makuahine (Hawaiian)
Anya, Fu (Hungarian)
Ibu (Indonesian)
Aiti (Finnish)
Madre (Spanish)

There are many ways to say "mother"...

No. 27

27

. . . and they all mean you will do anything for
the child who learns to say it.

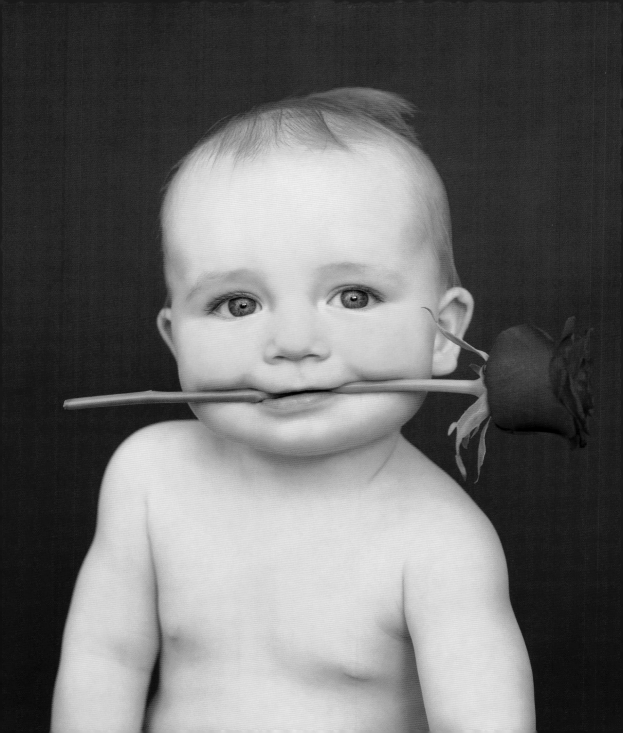

Babies make faces "only a mother could love"...

No.28

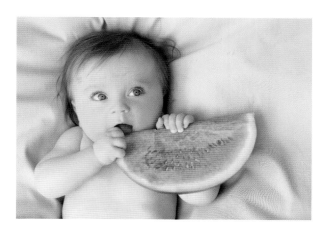

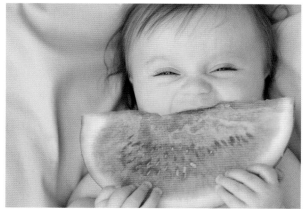

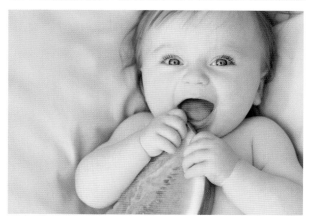

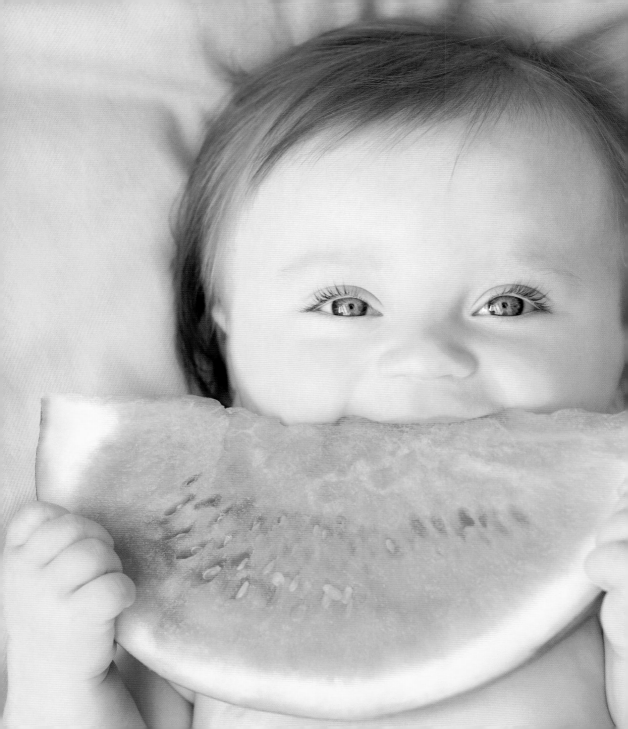

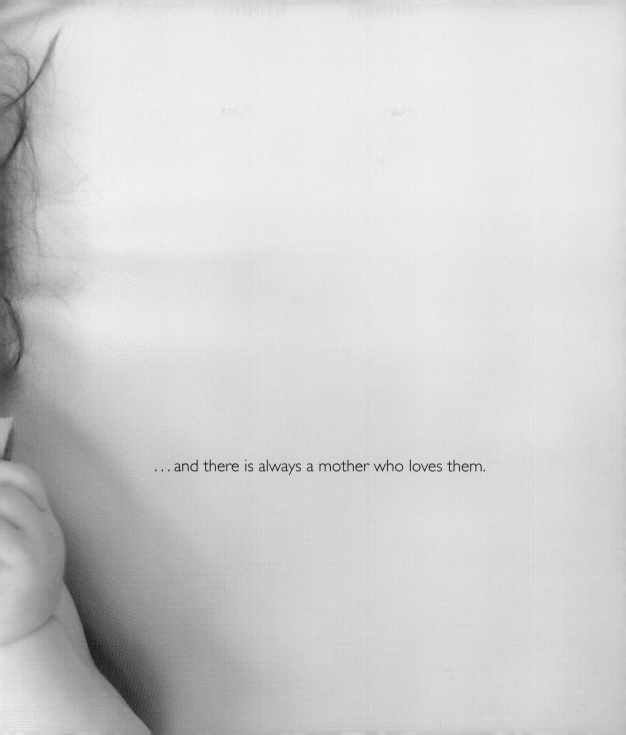

…and there is always a mother who loves them.

Take comfort . . .

No.29

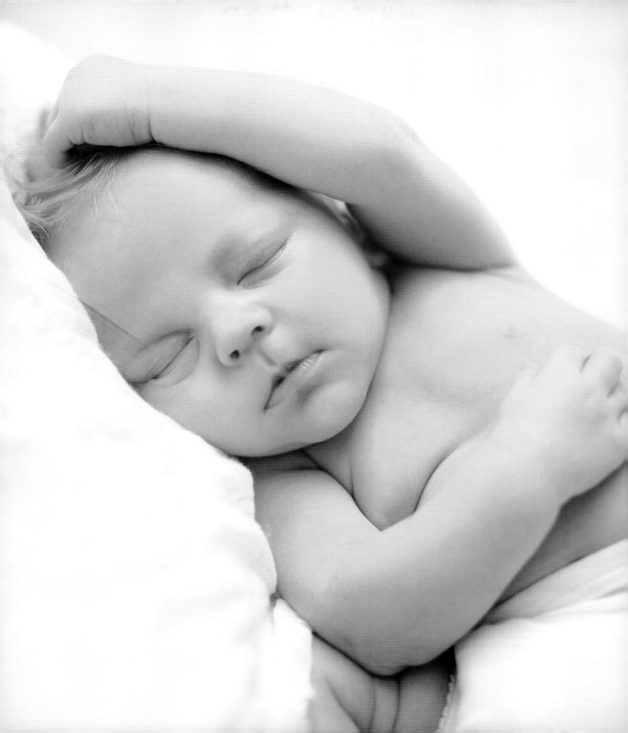

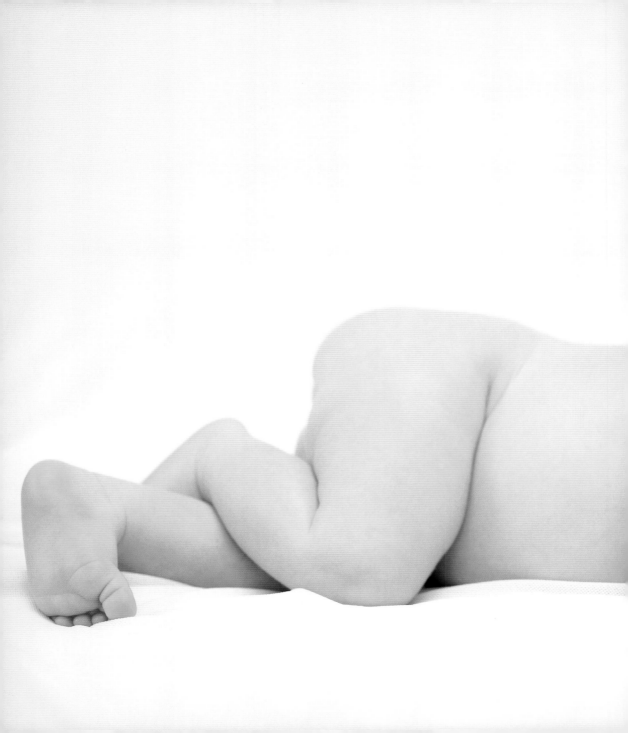

. . . every now and then your baby WILL sleep like one.

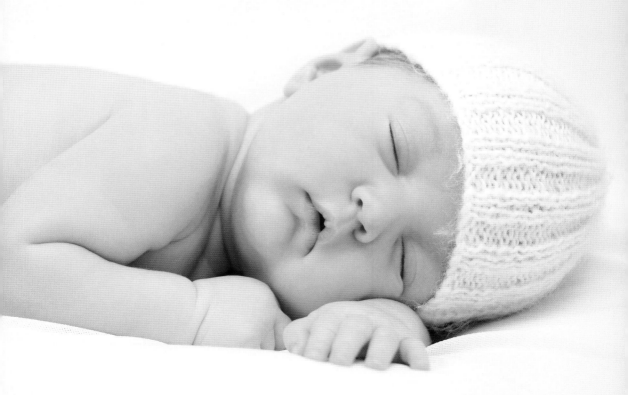

When there is a baby in the house . . .

No. 30

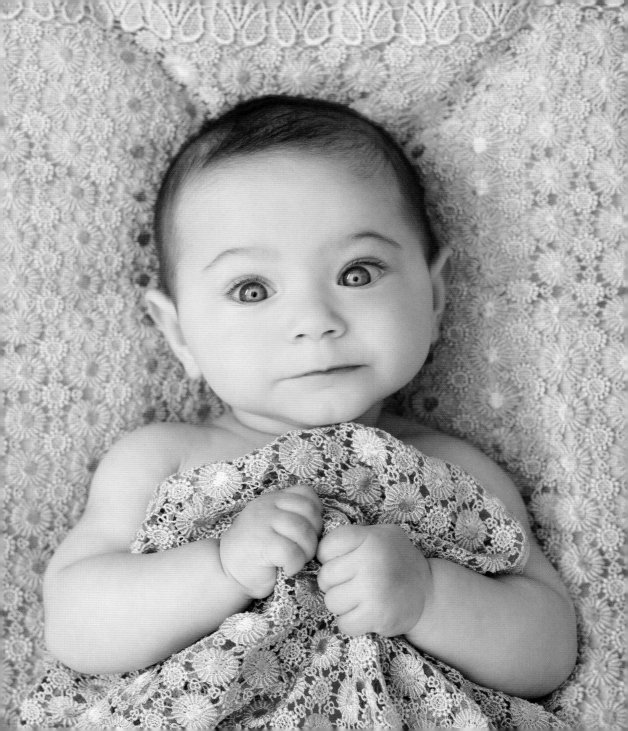

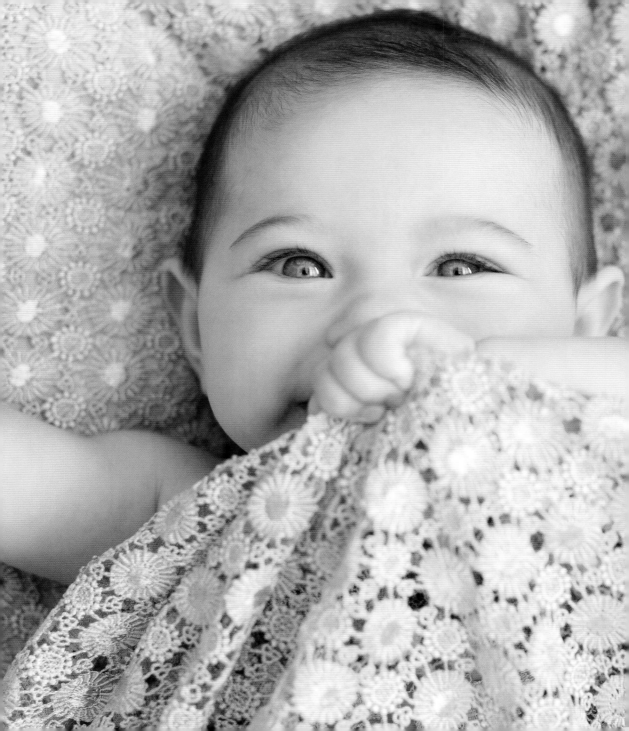

...you are never more than five minutes away from a smile.

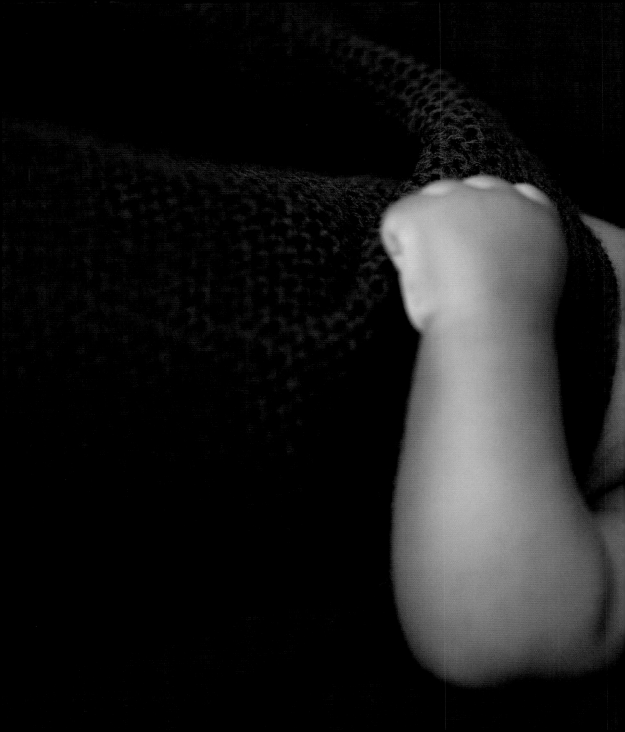

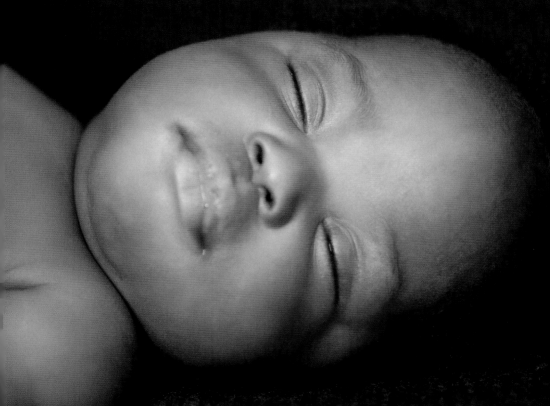

No. 31

Don't get hung up on what the "average baby" is doing …

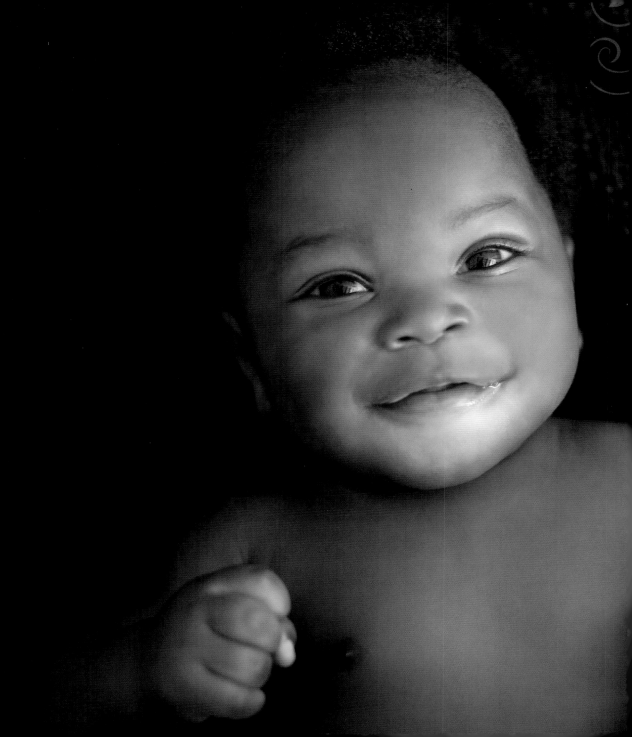

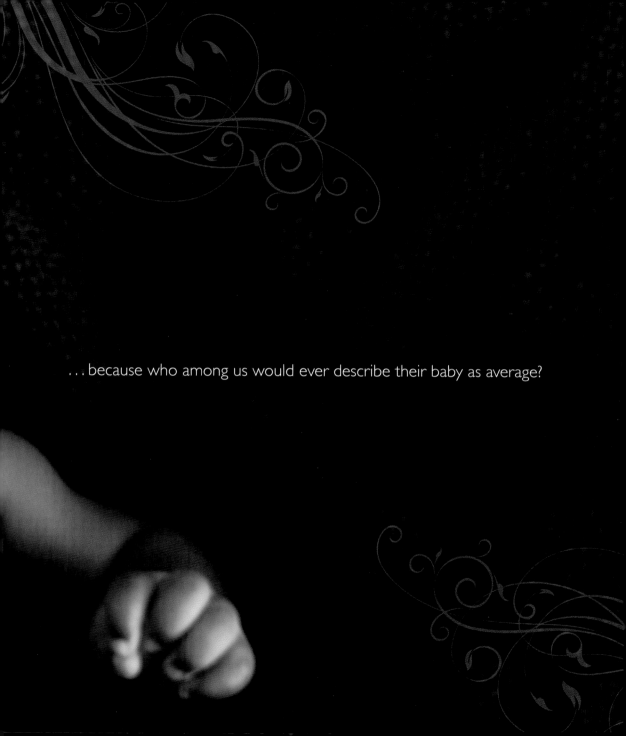

...because who among us would ever describe their baby as average?

*Spending time with other moms
is very reassuring.*

No.32

There is always someone with a baby that sleeps less than yours, and even if your baby isn't the one sleeping twelve hours straight . . .

. . . she's still the cutest!

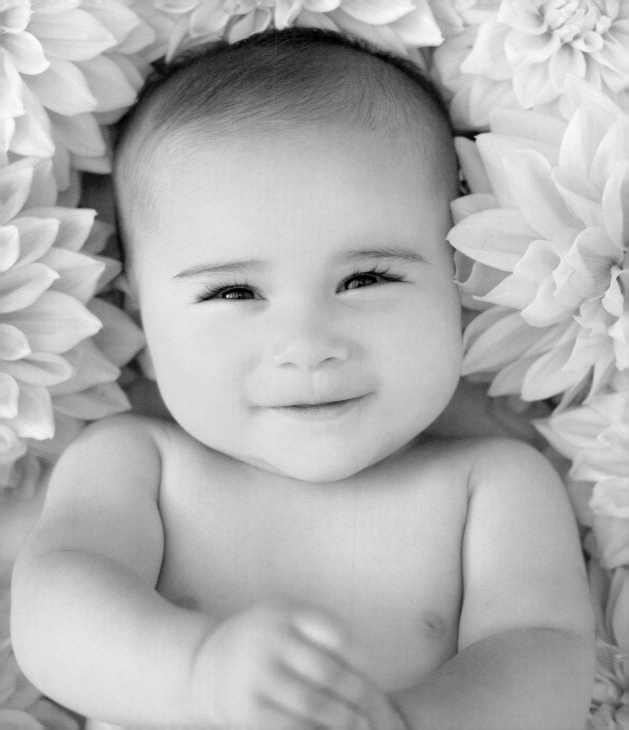

How to Make a Family

1. Take at least one baby.
2. Add a room.
3. Remove all unnecessary sleep.
4. When you think you've removed all unnecessary sleep, remove even more!
5. Add a lifetime of love . . .
6. . . . and an ocean of laundry.
7. Trim away all surplus funds.
8. Stir in dollops of laughter . . .
9. . . . and a healthy dose of cooperation.
10. Repeat steps 1–9 as often as desired.

No. 33

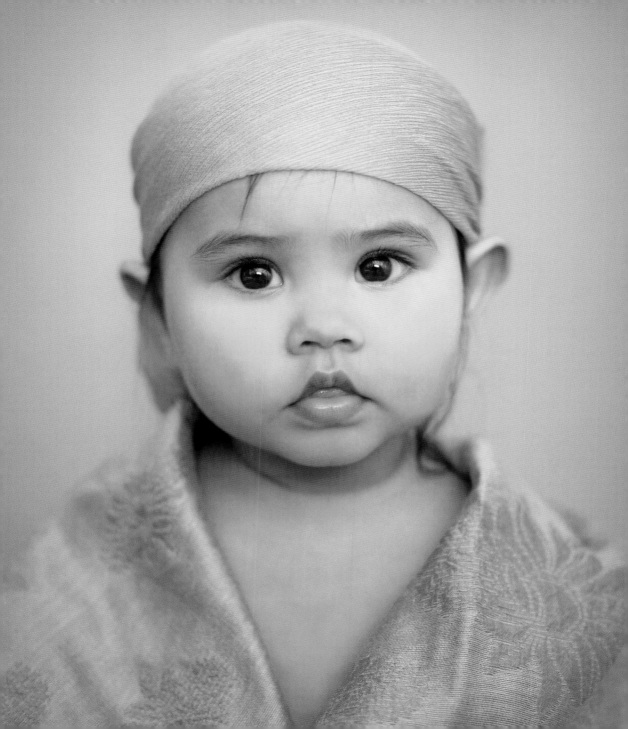

Congratulations! You now have
"Mom Super Powers"!

No. 34

You know where everything is in the house . . .

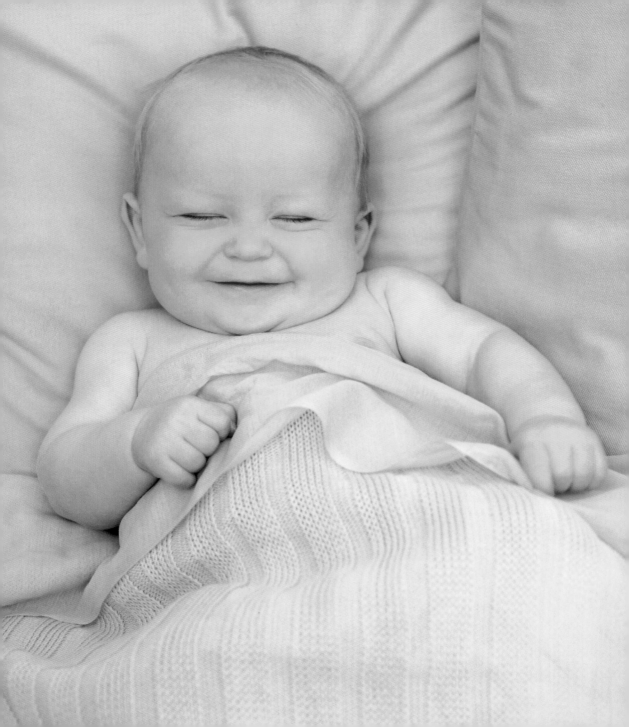

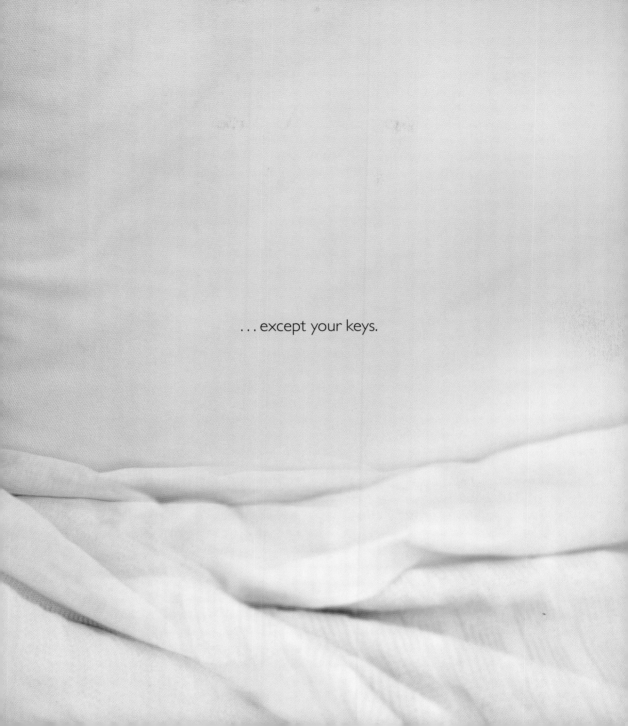

. . . except your keys.

The Baby Guarantee

To exceed your expectations and forgive your limitations.

No. 35

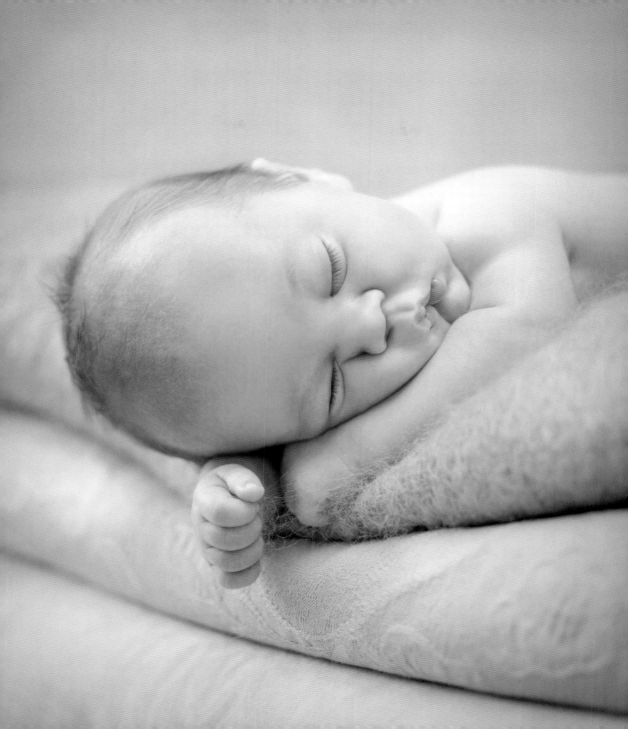

*Never share potential baby names
with your friends.*

They always know someone with a dog
named exactly what you have chosen.

No. 36

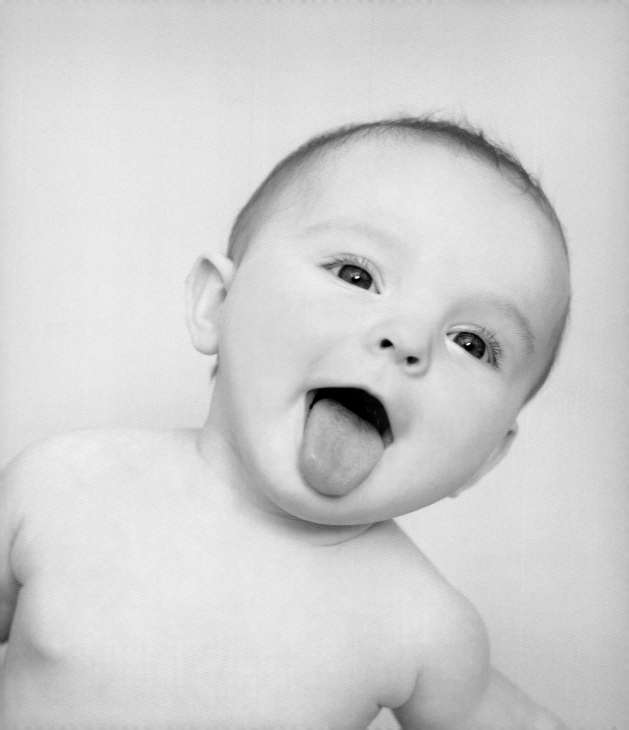

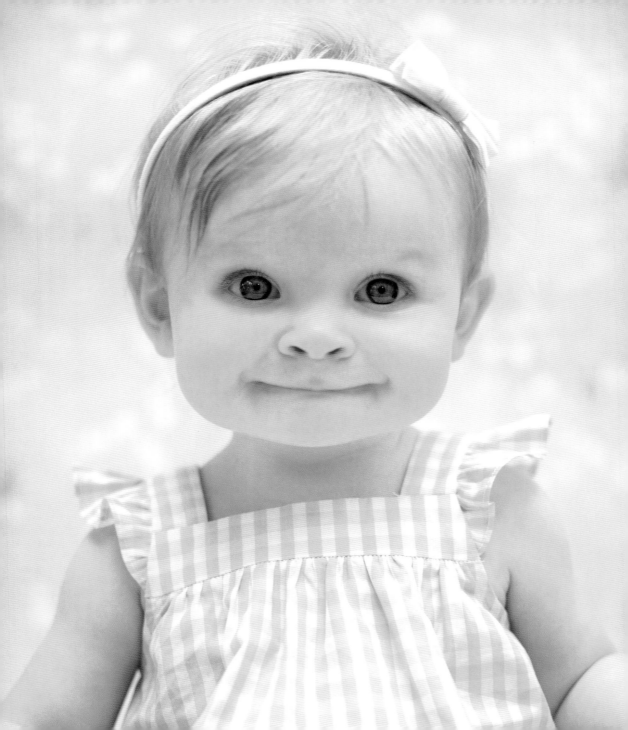

Happy Mother Recipe

1. Take at least one baby (prepared earlier).
2. Add one mother (slightly tired).
3. Tenderize with love.
4. Baste with kisses.
5. Challenge sanity with sleep deprivation.
6. Reward with smiles.
7. Stir in patience to taste.
8. Add a pinch of time.
9. Allow to rest somewhere warm for as long as possible.
10. Repeat steps 1–9 and expect a miracle!

No. 37

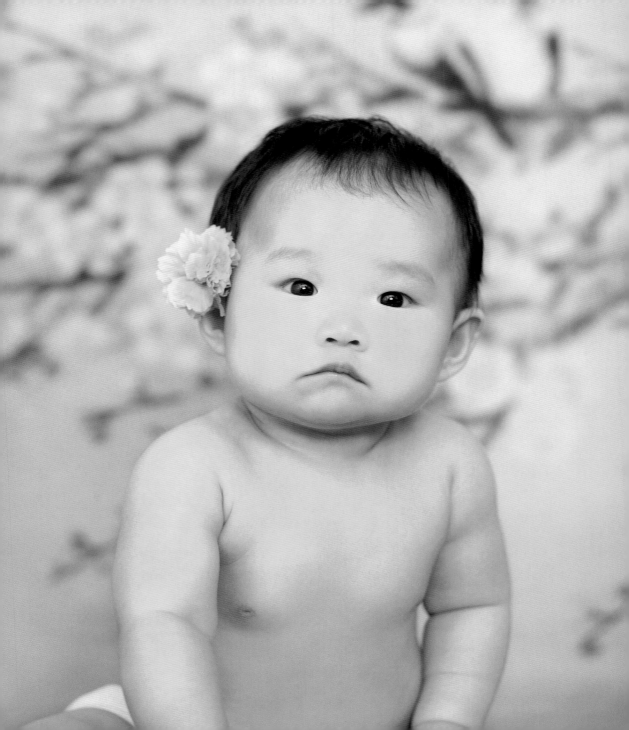

*It is possible to decipher
what your baby is really thinking:*

"Don't make me use the trembling-lip technique."

No. 38

"Does my butt look big in this?"

No.39

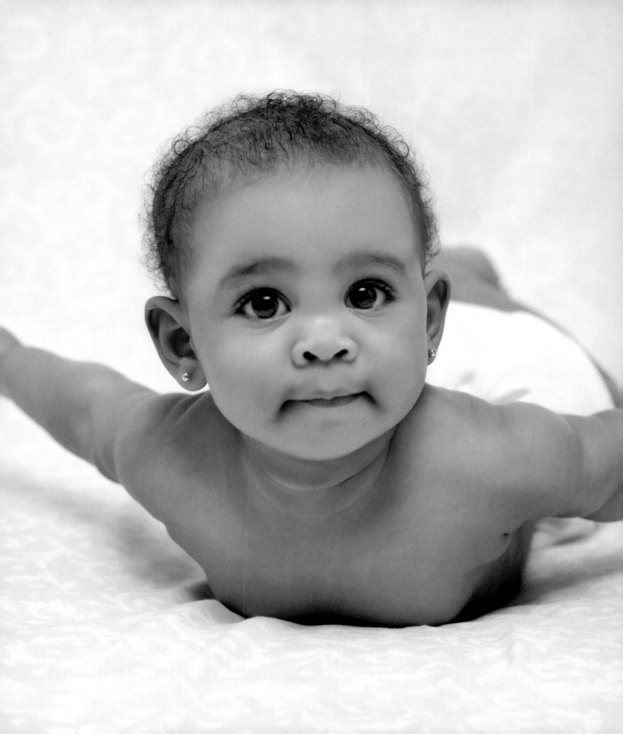

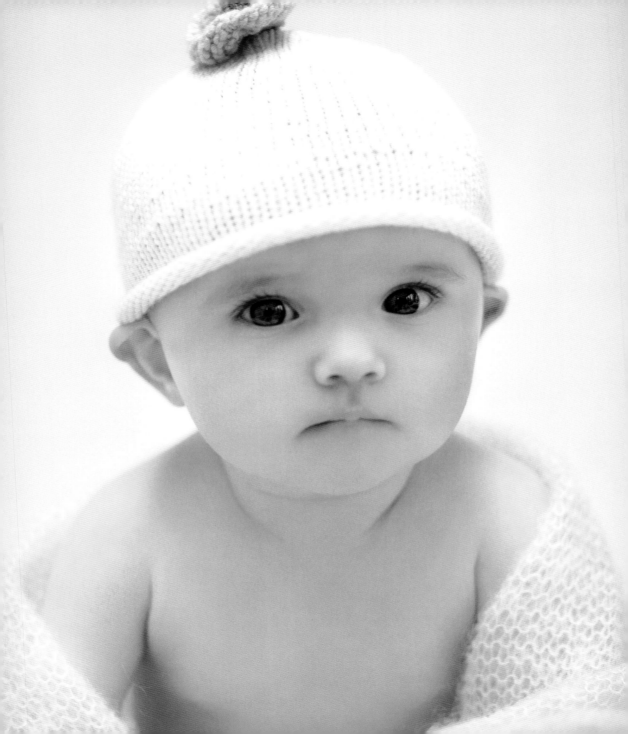

"Is this a real pashmina?"

No. 40

"I've heard I'm cute, but take a look at this babe!"

No. 41

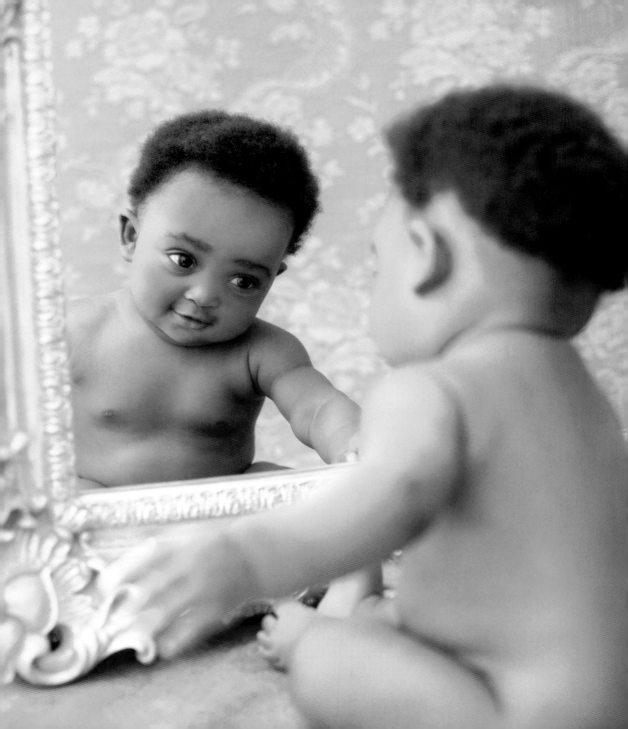

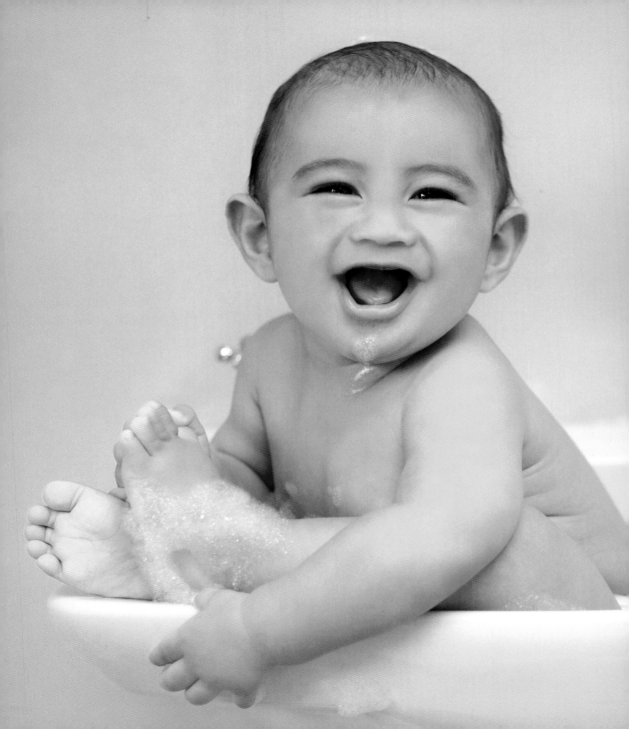

"I'm thinking it's bath time ALL day!"

No. 42

Your Mantra for Early Days

Feed the baby.
Change the baby.
Turn the baby over.

No. 43

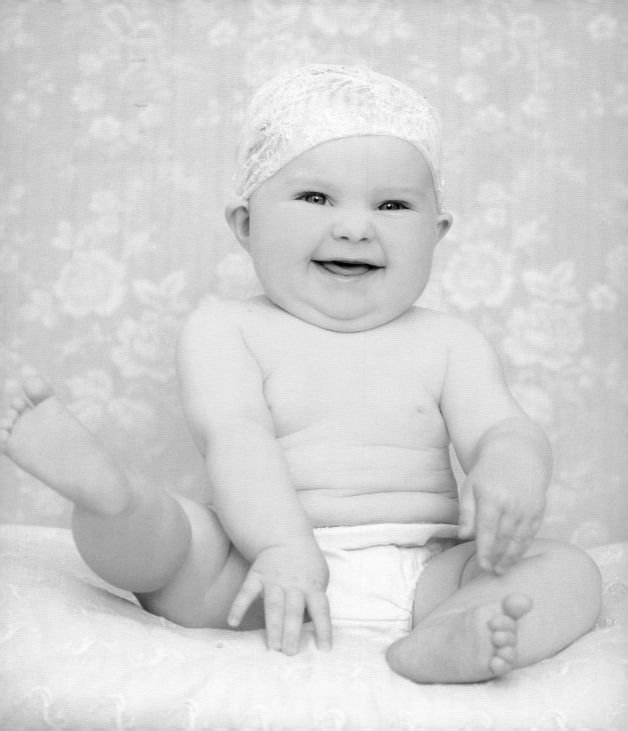

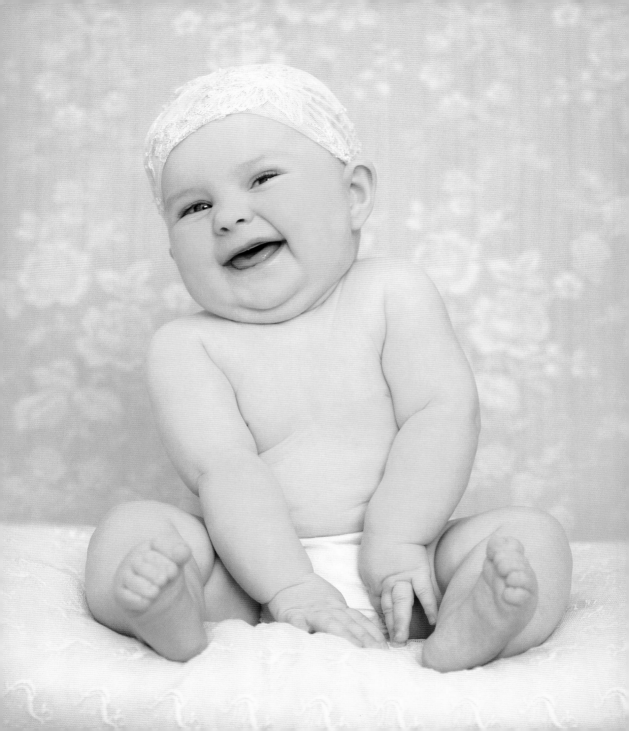

Your Mantra for Later Days

It's just a phase . . .
It's just a phase . . .
It's just a phase . . .

New moms have love handles because

No. 44

there is so much new love to handle.

Behind every happy baby
is a happy mother.

No. 45

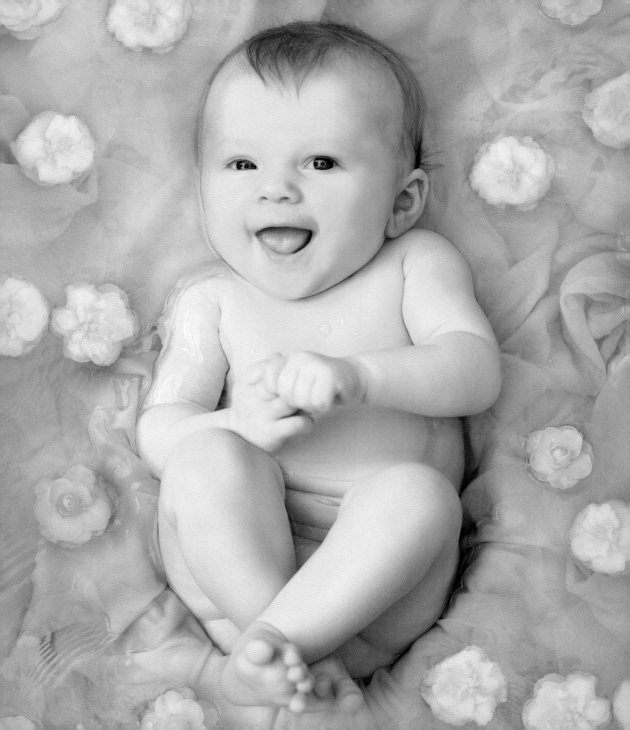

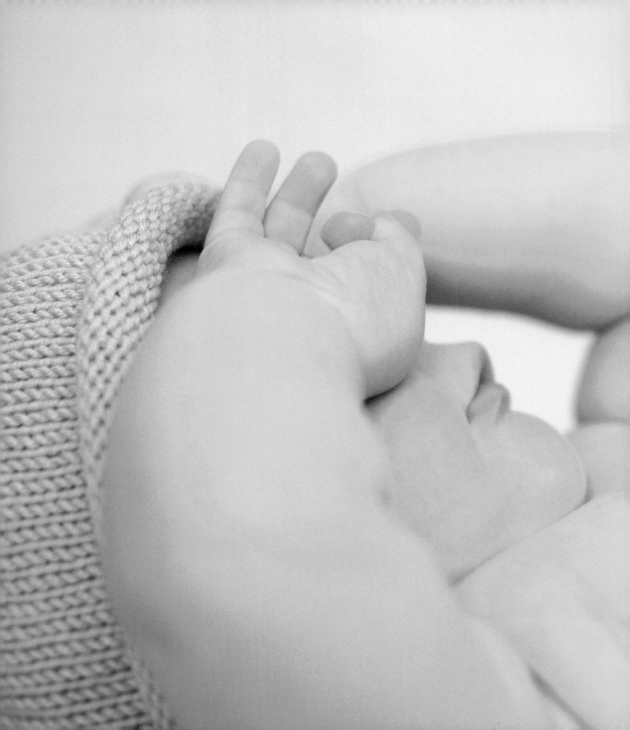

No. 46

Life has never been more challenging . . .

. . . and there has never been a greater reward.

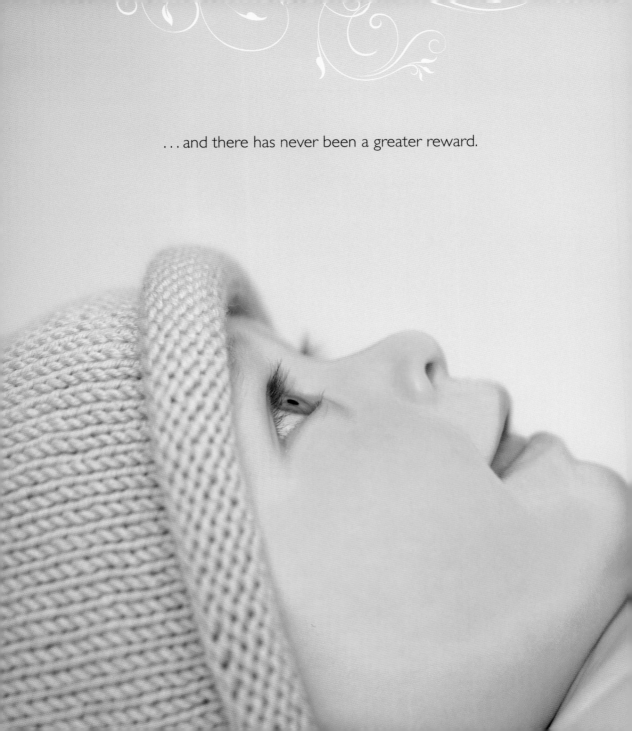

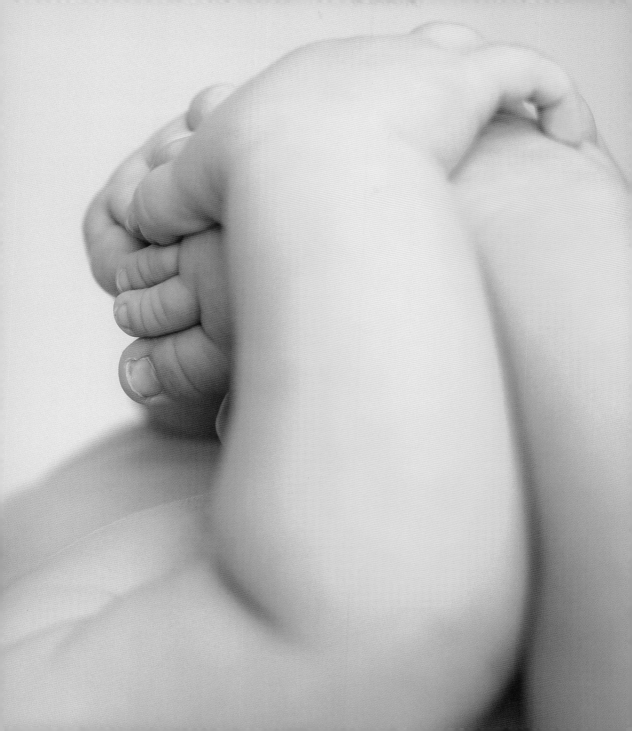

When in doubt . . .

No. 47

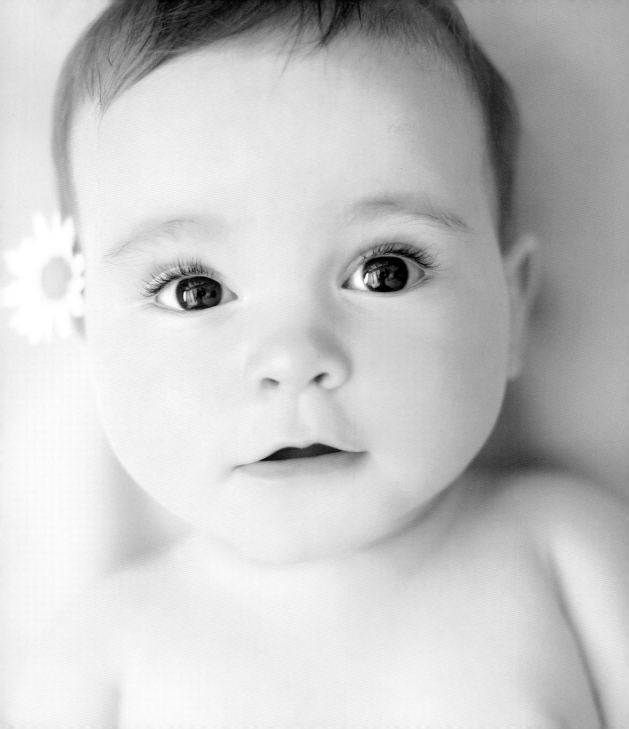

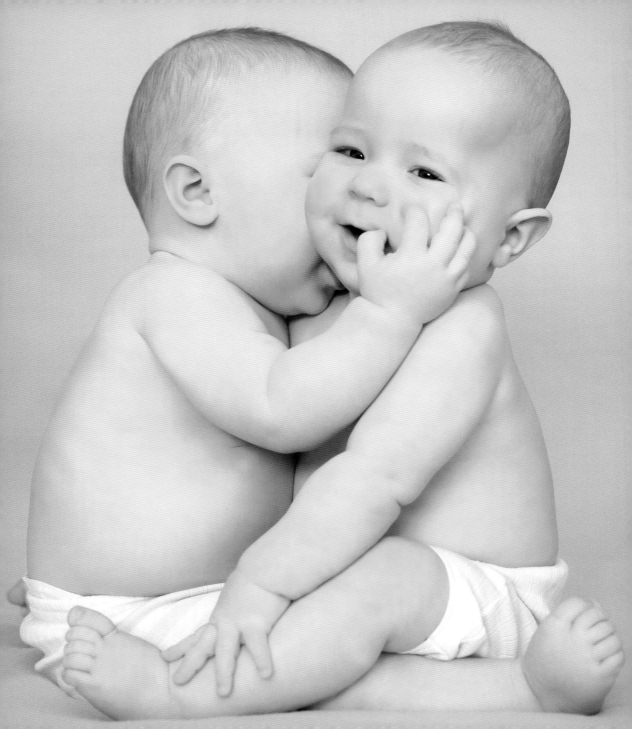

. . . cuddle.

No. 48

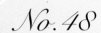

*Motherhood is the educational equivalent of
a college degree. You will graduate with . . .*

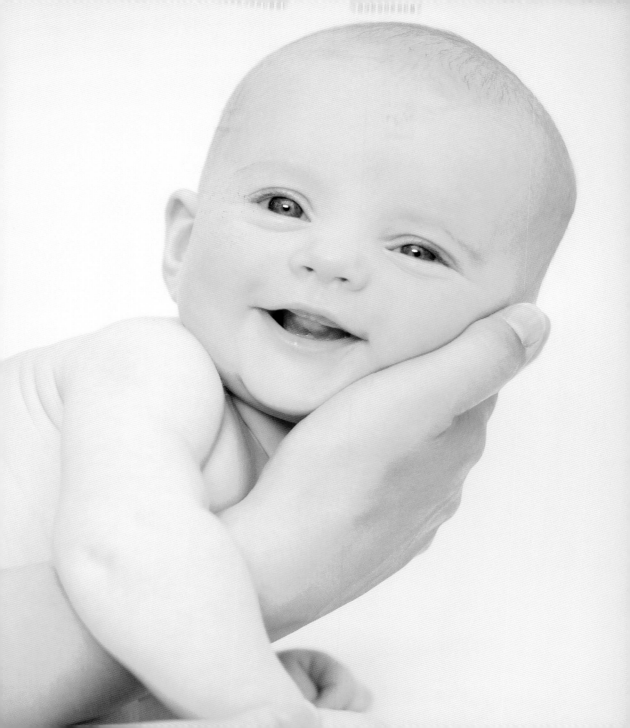

The organizational skills of a presidential campaigner.
The time-management expertise of an airport traffic controller.
The budgeting talents of an accountant.
The stamina of a marathon runner.
The poise of a Renaissance Madonna.
The creative dexterity of an artist.
The patience of a saint.
The courage to be as protective as a wildcat.
The ability to sleep anytime . . . and wake up just as quickly!
The foresight to be prepared for anything.
The flexibility to be ambidextrous.
The understanding of a completely new language.
The wisdom of what can really be done in ten minutes.

No. 49

THE MOTHERHOOD
EMPLOYMENT CONTRACT

Mother required for immediate start.

Term of contract: infinite.

Compensation: you will be working for love.

On-the-job training provided, no previous qualifications
or experience necessary.

Own car essential; must be prepared for said car
to depreciate rapidly.

Working-wardrobe requirements: we recommend machine-
washable, loose, comfortable clothing in dark colors.
Be prepared for new and unusual stains.

Availability: must be available twenty-four hours a day, seven
days a week, with the potential to work the occasional
twenty-eight-hour shift.

Overtime rates and holiday pay: n/a.

Never forget

No. 50

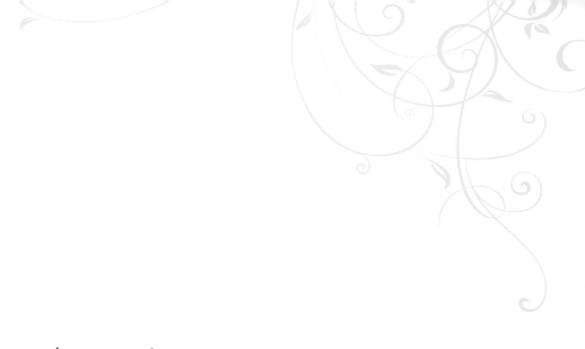

there is only one perfect baby in the world . . .

. . . and you're very lucky to have him!

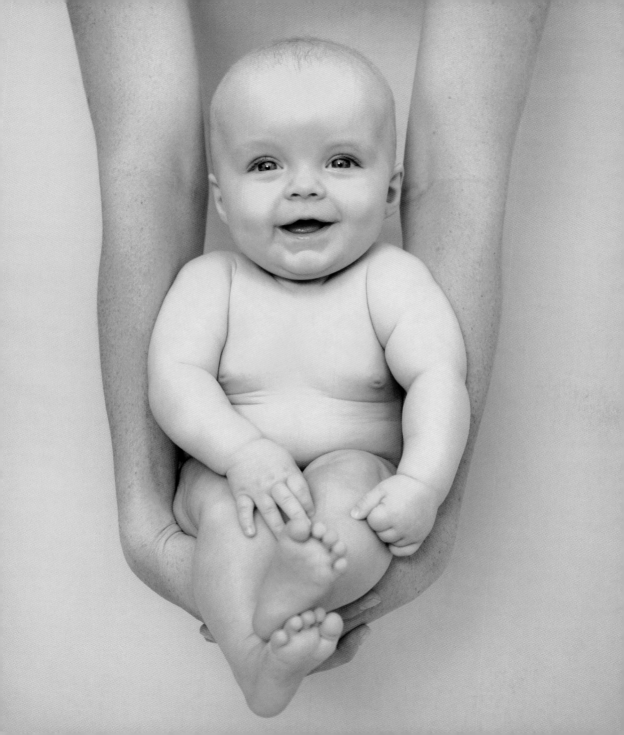

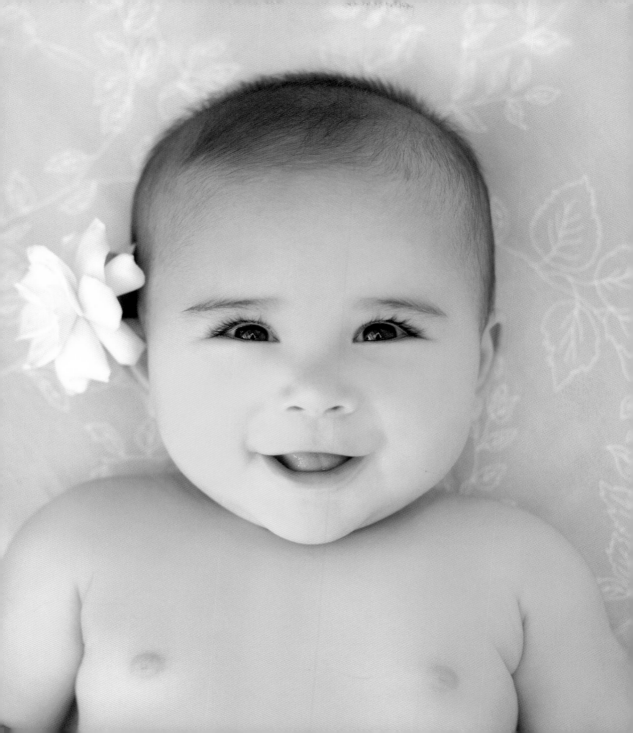

Acknowledgments

With this second baby project, I have truly come to LOVE babies. I have always thought them gorgeous, but now I have developed such a fondness for their adorable characters and their contagious giggles that I actually experience withdrawal symptoms if I don't photograph a baby for a few days!

There are so many people who need to be thanked when creating images for a book that I never know where to start.

The creation of my images would not have been possible without my faithful assistants, Nathalie Giacomelli, Jasmine Vette, and my newest absolute godsend, Jani Shepherd. Thank you, Jani. You have come to work for me during my busiest time ever, and have embraced the job with such enthusiasm and stamina that you have amazed me! I'm really looking forward to working with you on many more projects in the future.

Geoff Blackwell and Ruth Hobday, thank you from the bottom of my heart. As always, you have both been endlessly encouraging, and understanding of the challenges creating a book like this can bring, and no matter what arises your belief in me astounds me. Jenny, Sonia, Rachel, and the rest of the team at PQ Blackwell—thanks for being such amazing people to work with, and for welcoming me into the PQ family.

An ENORMOUS thank-you to all the babies who have been involved in this project. I love watching you grow up and develop into little individuals. I hope that one day you will look back on the photographs I have taken of you, and smile at how adorable you were. To the mothers and fathers, many of whom have become great friends, thank you.

Another big thank-you to Susan Christensen and your team of florists at Flowers on Franklin for all your amazing flowers; to Jazmin and the other girls at Global Fabrics for all the incredible fabrics supplied for backgrounds and props; and to the numerous midwives, especially Jan Smit, for enthusiastically telling new mothers about this project, and sending them my way.

Thank you to my family and friends—especially my parents, Barbara and Bob, who still after all these years delight in the tales I tell of my photo shoots; and to my twin sister, Rebecca, who is always there if I need advice and support. To my best friend, Jo, and her husband, Rawdon; the time I spend with you and your adorable children gives me such pleasure. You both should be so proud of yourselves—your children are three of the most beautiful and special beings to grace this earth.

Last but not least, thank you to my gorgeous, loving, and incredibly caring husband, Andrew. I am so looking forward to having our own wee person together and sharing many exciting family adventures in the future. I love you dearly.

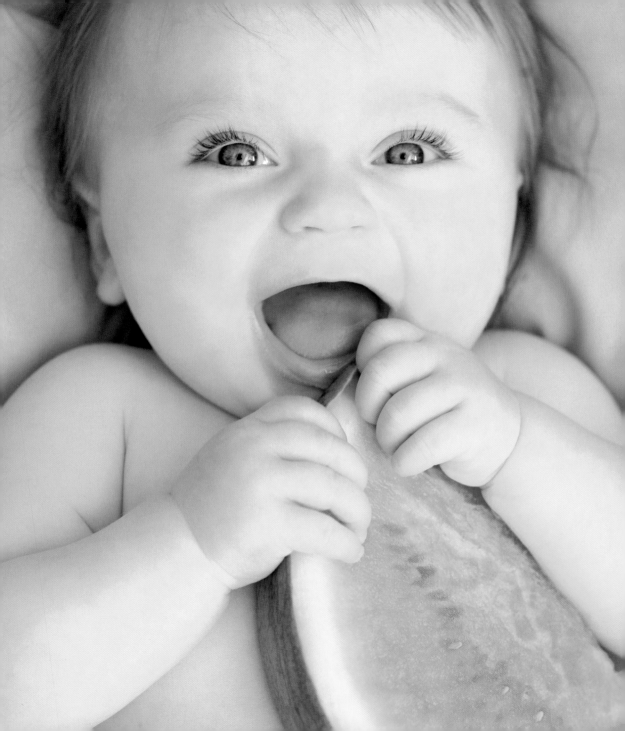

The Happy Baby Gallery

In order of appearance

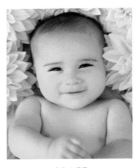

GRACE
6 Months

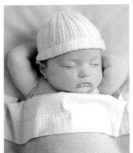

NINA
1½ Months

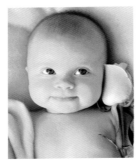

ISABELLA
3 Months

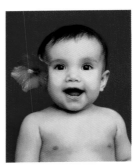

MAIA
10 Months

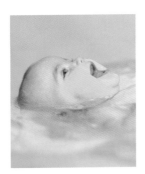

HOLLY
6 Months

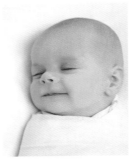

BENJAMIN
2 Months

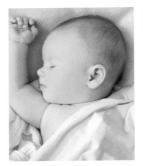

ISABELLA
3 Months

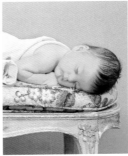

MICHAELA
2 Months

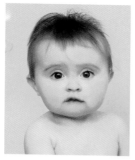

TESSA
7 Months

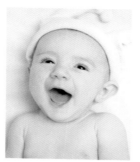

NICOLAS
4 Months

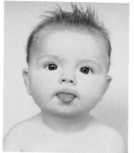

BAILEY
6 Months

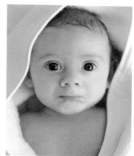

THOMAS
4 Months

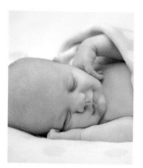

COOPER
1 Month

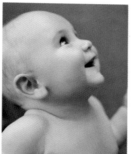

JACK
7 ½ Months

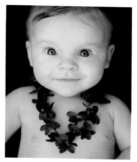

VIOLET
3 ½ Months

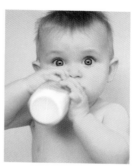

KIERAN
8 Months

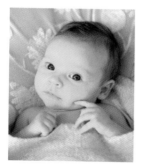

VIOLET
1 ½ Months

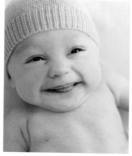

MIA
4 Months

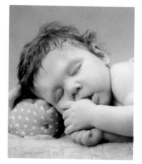

JOE
2 ½ Months

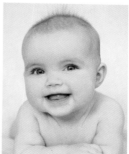

HOLLY
5 Months

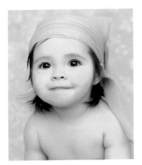

TAYLA

8 Months

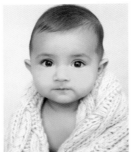

PHOENIX

5 Months

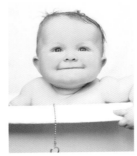

RITA

9 Months

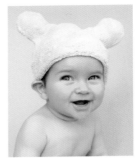

HARRISON

8 Months

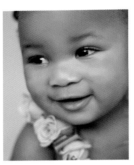

HANNAH

7 Months

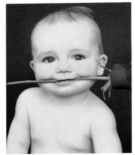

ELIJAH

8 Months

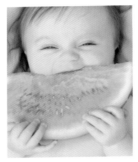

CHLOE

5 ½ Months

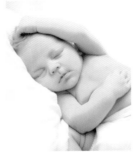

LEO

4 Weeks

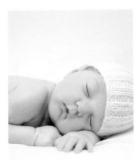

NINA

1 ½ Months

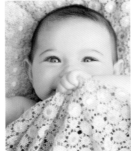

GAIA

6 Months

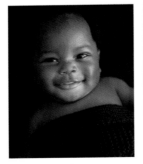

ISAIAH

3 Months

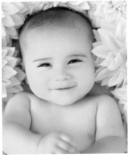

GRACE

6 Months

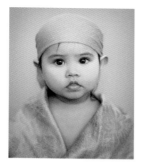

MEERABAI

9 Months

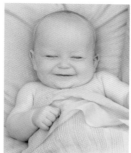

BEN

6 Months

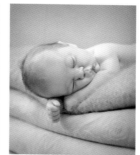

CHARLIE

2 Months

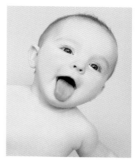

GEORGIA

7 Months

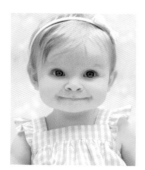

VIOLET

7 ½ Months

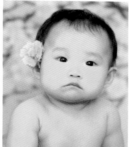

CHAOYI

6 Months

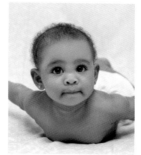

SAADIYA

6 ½ Months

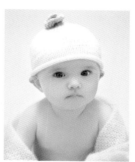

ANIKA

7 ½ Months

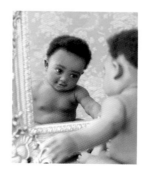

MICHEALA

5 Months

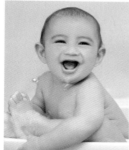

PHOENIX

6 Months

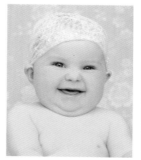

GEORGIA

5 ½ Months

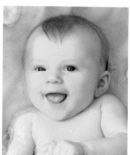

EMILY

3 ½ Months

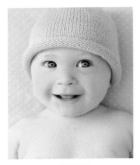

LATHEM
6 Months

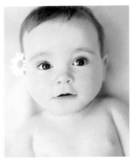

DANIELLE
6 Months

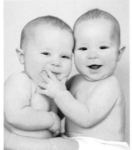

BEN & SAM
8 Months

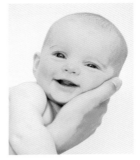

HOLLIE
3 ½ Months

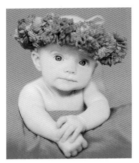

HOLLIE
3 ½ Months

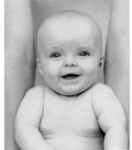

THOMAS
4 ½ Months

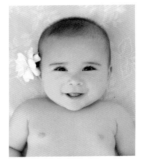

GRACE
6 Months

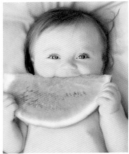

CHLOE
5 ½ Months

Dedication

For Mia (featured on pages 51 and 52), one of the strongest, most courageous, and most enchanting little girls I have ever had the pleasure to photograph—RH

For my shining pearls, Pipi and Shae—SB

For Bruno and Michael, who made me a mom—BL

This edition published in 2009 by Andrews McMeel Publishing, LLC,
1130 Walnut Street, Kansas City, Missouri 64106
www.andrewsmcmeel.com

ISBN-13: 978-0-7407-8512-2
Library of Congress Control Number: 2009924137

Produced and originated by PQ Blackwell Limited,
116 Symonds Street, Auckland, New Zealand
www.pqblackwell.com

Concept book design by Cameron Gibb.
Additional book design by Emma Hansen-Knarhoi.
Printed by Midas Printing International Limited, China